HIDDEN

HISTORY

of

MILWAUKEE

W9-AVI-380

HIDDEN
HISTORY
of
MILWAUKEE

Robert Tanzilo

The History
PRESS

Published by The History Press
Charleston, SC 29403
www.historypress.net

Back cover, top: Courtesy of Historic Photo Collection, Milwaukee Public Library.
Much of this work previously appeared, sometimes in different forms, at OnMilwaukee.com
and is included here with kind permission. All images are courtesy of the author unless
otherwise noted.

First published 2014

Manufactured in the United States

ISBN 978.1.62619.451.9

Library of Congress CIP data applied for.

For Arthur Holtz, because whenever I've been up high, gazing out over this city, I wish I could tell him about it afterward.

Contents

Acknowledgements

Above all, as always, I owe a debt of gratitude to my family—Kathy, Luca and Valentina—for making time for me to get this done.

A big thank-you is also in order for Andy Tarnoff, who as publisher at OnMilwaukee.com, has always allowed me to follow my muse and has offered kind permission to reprint work here that first appeared at OnMilwaukee.com. Thanks also to my OnMilwaukee.comrade Molly Snyder for her valiant duty as my occasional photographer on the missions collected here. (Andy's done that duty, too.)

I couldn't have done these pieces without the assistance of my tour guides, most of whom are named in their respective chapters, and without the help of the folks at Historic Milwaukee Inc., especially Amy Grau, who, as the coordinator for the annual Doors Open Milwaukee, has a Rolodex of names and numbers that quite literally opens doors throughout this town—a massive shout-out to them all. A kind nod of gratitude to Brooke VandeBerg, Mary Milinkovic and the staff at Milwaukee Public Library for graciously granting permission to use photographs from their collection. Thanks also to Robert Kennedy at WE Energies and to William Coughlin at AT&T.

Thanks, finally, to the entire team at The History Press, with whom it's always a pleasure to work.

Introduction

History is all around us. Sure, it's a cliché, but it's true. In Milwaukee, as in all places, history is not only in the buildings we see every day but also in the absence of the buildings they replaced or once stood beside. It's in the names of streets, and it's hidden in the bones of the city. It's in us. It is us. We are writing the history of the future.

When I started to write these pieces for OnMilwaukee.com, I ran them under the banner "urban spelunking," not because I was breaking into forbidden places and not because I was exploring actual caves—though I did the latter (but never the former) a couple times—but because I was looking for history in the everyday places of the city: in the landmarks we celebrate, in the familiar places we take for granted and in some typically off-limits places we all are curious about seeing. It felt a bit like spelunking in broad daylight.

I hope that opening some of these doors and shining a light on some of these places helps us get a better feel for the history of Milwaukee and for the flavor of this town. At the very least, I hope the journey is as fun for you as it's been for me.

Where Milwaukee Was Born

Digging Down into Water and Wisconsin

Don't feel bad if you've never seen the plaque affixed to 100 East Wisconsin Avenue, explaining the historical relevance of the northwest corner of Water Street and Wisconsin. It's on the lower level of the building, facing the RiverWalk. I've passed it countless times and never noticed. Its greenish-brown patina makes it easy to miss.

But one day, it caught my eye. I photographed it and then spent some time digging to fill in a bit more of the story of this corner that is the birthplace of modern Milwaukee.

Our story begins with Antoine François LeClaire, who was born in 1768 in St. Antoine De La Rivière du Loupe, Louiseville, Quebec. By 1795, when his son François was born, LeClaire was in St. Joseph, Michigan, straight across the lake from Chicago.

But by the time his third child—daughter Josette—arrived in December 1799, LeClaire was in Milwaukee. LeClaire's wife, Marie Savagesse, was a member of the Potawatomi tribe, which presumably explains her unusual—and to modern ears, politically incorrect—surname.

In 1800, LeClaire built a log cabin on the Milwaukee River, on the site of the current 100 East Wisconsin office tower. Not only was that modest cabin the first house built on the east side of Milwaukee, but it was also, presumably, the first commercial building.

Though there were certainly indigenous people living in the area—including residents of a Potawatomi settlement directly across the river, according to an April 1920 article by Publius V. Lawson published in the

Wisconsin Archeologist—because LeClaire selected the site for his cabin, it seems unlikely any lived on the piece of land in question.

Some have claimed that LeClaire's son Antoine (Jr.) followed in his father's footsteps, opening his own trading post to make deals with the local Native Americans, at the precocious age of twelve.

Soon, the LeClaires had company. Another Québécois, Solomon Juneau, had arrived in Milwaukee in 1818 as a representative of the American Fur Co. Some accounts say that Juneau built a cabin next to LeClaire's at this time, though other versions are contradictory.

In 1820, Juneau married Josette Vieau, whose father, Jacques, built a cabin in 1795 on the bluff above the Menomonee Valley in what is now Mitchell Park, where the couple lived for a while. There is another plaque that marks that site. After a few years traveling between posts in Wisconsin, the Juneaus returned to Milwaukee.

In 1825, Juneau erected a cabin, stockade and store, just east of the LeClaire place, facing what is now Water Street. Ten years later, he added a large warehouse.

LeClaire left Milwaukee and married twice more, in 1819—in Portage des Sioux, Missouri—and in 1821, and some of his children became well-known businessmen and philanthropists in the upper Midwest.

But Juneau stayed later in Milwaukee and left a more indelible mark, establishing his Juneautown east of the Milwaukee River. He merged it with Byron Kilbourn's Kilbourntown on the opposite shore and George Walker's Walker's Point in 1846 to create the city of Milwaukee, and he served as the new city's first mayor.

Nine years earlier, Juneau had provided the cash for editor John O'Rourke to start a newspaper called the *Milwaukee Sentinel*.

In 1848, after serving a two-year term as mayor, Juneau decamped to the town of Theresa, which he had founded in Dodge County fifteen years previous and where you can still see the home he built there.

In 1838, future governor Harrison Ludington arrived in Milwaukee from Dutchess County, New York, and became partners with his uncle Lewis Ludington in a general merchandise business that they ran out of Juneau's warehouse. In the late '30s, McDonald and Mallaby ran a corner store on the site, perhaps in one of the buildings Juneau built.

In 1851, the Ludington company erected a new warehouse on the site. It was, according to James Smith Buck's *Pioneer History of Milwaukee*, the second building in the city in which granite was used in construction.

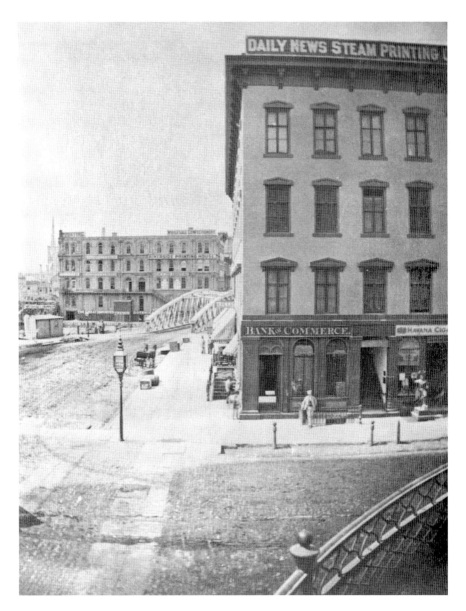

The 1851 Ludington block, seen here in the 1870s, on the corner of Water Street and Wisconsin Avenue was one of the most impressive buildings in early Milwaukee. It was replaced with the fourteen-story Pabst Building in 1891. *Courtesy of Historic Photo Collection, Milwaukee Public Library.*

The four-story building must have seemed like a skyscraper in Milwaukee in its day. In an 1870s photo in the collection of the Milwaukee Public Library, the building is adorned with a cornice, and on the ground floor, the Bank of Commerce and a cigar shop are visible. Along the roof is a sign advertising "Daily News Steam Printing." The building was a fixture downtown for forty years, when it came down to make room for the modern era.

That's when Chicago architect Solon Spencer Beman's 235-foot, fourteen-story behemoth, with its imposing Neo-Gothic features and an entry arch that appears to presage city hall's, went up on the site. From its completion in 1891 until city hall's topping off in 1895, the Pabst Building was the tallest in the state. It remained second tallest until the Schroeder Hotel (now the Hilton City Center) was erected in 1927. The steel frame building, heated by steam pumped from the Pabst Brewery, would remain an architectural touchstone in the city, influencing buildings constructed nearly a century later, notably its own replacement.

Alas, the year the Pabst Building turned ninety—by which time it had long since lost the decorative pinnacle of its tower—it fell to the wrecking ball, and the site remained dormant for years. A proposed development called River Place never got off the ground and the gaping hole was filled in and covered with grass and public art—including a wall-mounted mural that showed a different scene depending on the angle from which it was viewed—during the moribund years.

In 1989, Clark, Tribble, Harris & Li's 100 East Wisconsin was built to drawings that recalled the neo-Gothic roofline of the Pabst Building, albeit in a smoother-edged, less exciting way. The street-level arches echo the Flemish Renaissance features at the base of the Pabst.

At 549 feet tall, the 100 East Wisconsin building is more than twice as tall as the Pabst Building. If we estimate that LeClaire's cabin peaked at about 18 feet, the current building on the site is more than thirty times the size of the first to stand on the corner of Water and Wisconsin.

Captain Frederick Pabst understood the importance of the site where he built the tower that bore his name. He's the one that in 1903 paid for the plaque that survives today, long after his skyscraper became little more than a memory.

Scaling City Hall Tower

With all due respect to Santiago Calatrava and the Milwaukee Art Museum, homegrown architect Henry Koch created what has long been the symbol of Milwaukee, our towering city hall. In addition to making a major architectural statement to the world when it was built in the 1890s—it was among the world's tallest buildings upon its birth—it has since remained a testament to the city's German heritage. In fact, its Flemish Renaissance Revival style recalls the great rathaus in Hamburg, with a bit of Romanesque flair added by Koch, who often worked in that milieu.

Soon, if Paul Jakubovich of the city's historic preservation office gets his way, the city hall will house a museum celebrating its history. Jakubovich has a plan and is working to raise private funds to make the museum, which would be located in the building's lower level, a reality. In the meantime, there is a panel in the lobby with some historic photographs.

"If I can get the funds raised, and…we think we can get the money fairly quickly, and then we open," said Jakubovich. He continued with details:

We've already discovered that there is a marble mosaic floor that was down there that no one knew was there and covered up for probably seventy to eighty years. We had all of that taken up, and it's been restored. And the next phase will be constructing walls and ceilings. There will be a small movie theater in there. Our Channel 25 cable station across the street is going to be doing some videos for us, which will be really nice.

When you come to city hall, you'll be able to get lots of information. We have a visitors' bureau as you know, but city hall is kind of this big prominent building that everybody knows. They see it, but many haven't been into it, and I think that this is a way of making this more of a destination, as opposed to a place where you only go to pay your taxes.

Jakubovich said the museum won't be a dry look at an admittedly tall pile of bricks and mortar. The goal is to make it much more engaging, drawing in the role the building has played in the history of the city: "The stories that we're going to tell in our museum are not only about the architecture of the building but also of the people who built it, the government and significant events that took place here."

Did you know that for more than a century tourists have climbed the tower (which reaches the height of a thirty-four-story building) to get a look out across the city from the observation deck? Did you know that up at the next level, couples have exchanged wedding vows next to the giant bell?

It took very little coaxing to get Jakubovich to lead a tour of the city hall tower, which is a dizzying array of ladders once you exit the elevator on the top floor of the building, just above the skylight that illuminates the soaring atrium in the main building.

Entering into the tower from that level, there's an ornate iron staircase that ascends up into darkness, though its lower section is in the middle of a big bright cube of space that is the interior of the tower. Here you can see the brickwork, including the brick relieving arches that allow such a tower to stand by lessening the downward force that would love to explode the walls outward. Also on this level is a fairly large apartment with great views south down Water Street, east to the lake and west over the Pabst Theater.

"This was for a caretaker," Jakubovich said of the apartment. "And they ultimately had a kid up here, and I guess he became an engineer with the Department of Public Works when he grew up. I'm not sure if he's still alive or not; he'd have to be about ninety years old."

Right outside the apartment door is the staircase, which appears to ascend to nothingness. As I mentally cued up Jimmy Page's intro to "Stairway to Heaven," Jakubovich said, "You'll notice that this staircase is actually pretty ornamental, and the reason for that is that this was the route the tourists would take to go to the observation platform, which is that next level above us. Many thousands of tourists probably a month

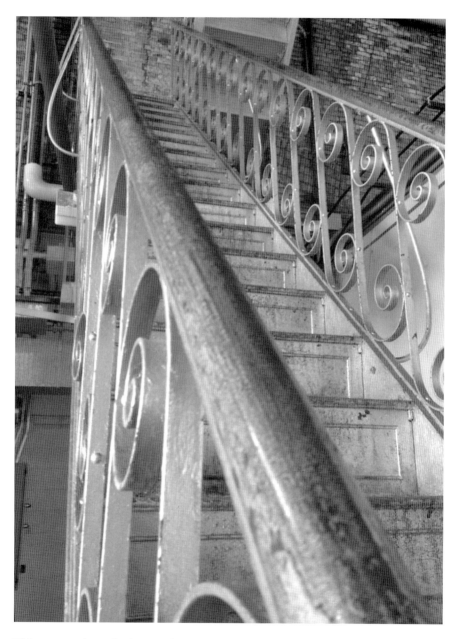

This ornate staircase leads up to the tower from the caretaker's apartment on the top floor of city hall. It is the first leg of a long journey up to the top of Henry Koch's 353-foot-tall bell tower.

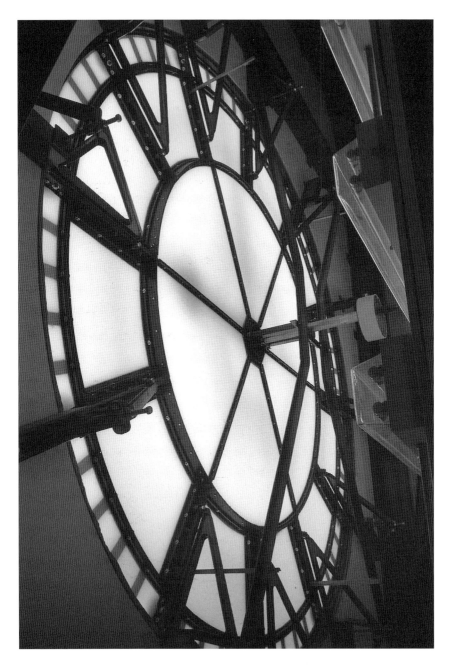

The four-faced clock tower on city hall was designed by Nels Johnson in his Manistee, Michigan workshop. Johnson, who built the clocks by himself, made nearly sixty of them, and his bells also hang in three Milwaukee churches. Here we get an up-close look at the back of the north face.

back then, about 110 years ago, would've gone up this staircase. [There are] substantially fewer than that now, but we're kind of looking at changing that, too."

Jakubovich said that public tours are still conducted to the observation deck and some folks even climb the spiral staircase to see the bell.

From the observation deck level, the view is nice, and you can see much of the detail work that has been in the news in recent years as city hall has undergone massive renovation and restoration work. Despite the fact that these spaces would have been way too high to be seen well back when Koch designed the building, the craftsmanship and attention to detail is amazing. Looking out to the north you can see the roof of the main building, and it's surprising how miniscule city hall's footprint appears to be from this vantage point.

On the next level, there isn't much to see, though decades of visitors have stopped to carve graffiti into the brickwork. You can continue up the spiral staircase to reach the bell. Higher up, the view is even better, and the bell is something to behold. Jakubovich gave us some of its story:

> This is the second-largest bell made in America at eight feet. The largest bell made in America is in St. Joseph's Church in Cincinnati. There are three other bells that are larger than this one or the one at St. Joseph's, which were imported from France. One of those is the world's peace bell, which is just outside Cincinnati and came to this country in the year 2000. It's about twelve feet in diameter. There are other bells bigger than this, too. One is in Chicago [in the] Rockefeller Memorial Chapel, and then one [is] at Riverside Baptist in New York. But as far as the American-made bells, this is the second-biggest one made.
>
> This one is supposed to be perfectly tuned, although people kind of disagree on what note. It's actually a very complicated musical instrument. It was made three times—this is the third casting of this bell. The first two castings were not satisfactory. They didn't like the sound, so they broke it up, melted it down and made it again. Part science, part art/craft and also a lot of luck.

Interesting, I thought.

"Would you like to ring it?" Jakubovich asked me.

"Excuse me?"

"Would you like to ring it?"

"Um, yes!"

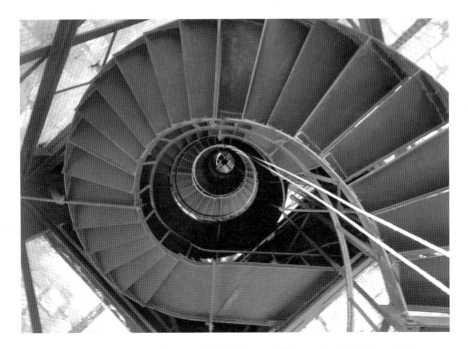

The last leg of the journey up the tower is this free-standing, vertigo-inducing spiral staircase that winds straight up the center of the tower above the level that houses the clock. At the top, a small space with windows offers fine views of downtown. The last few steps take you up to the base of the flagpole.

Jakubovich wisely reminded us that the bell is, naturally, very heavy and that after pulling the rope, we have to let it slip through our hands lest it grab us and send us hurling through the air.

It takes a few pulls to get the bell swinging enough to ring it. Working up to it, the anticipation is exciting and when the clapper finally kisses the bell's lip, the sound is glorious. I feel a bit like I'm screwing up the schedules of anyone who might expect the bell to sound the hour accurately and, at the same time, like I own the city.

At this point on the tour, there are two ways we can go: back down the way we came, or up, up, up.

Jakubovich said we were free to climb to the very peak of the tower, indicating a swirl of black iron steps that are not enclosed in any way, really. Slip through, and you're, well, through. Jakubovich said whatever we decided, he'd stay put.

OnMilwaukee.com's Molly Snyder, who tagged along to shoot photos, and I looked at each other and shrugged, saying, "How can we not?"

We started climbing, and I vowed not to look down. It was a promise I kept to myself, and I focused on placing each foot squarely on a step and repeating until I reached the top.

There we found a platform and some windows, which we opened to admire the view, thinking we were all the way up. Then we noticed more stairs, and of course, we climbed them. We opened the windows at the next landing and realized we were as far up as we could go, short of taking the last curve of just a few steps up to the absolute pinnacle. That was something we were advised not to do, and we obeyed.

Molly took some photos, and I thought for a moment of the generations of my Milwaukee ancestors who looked at this building from below. I felt a twinge of German Brew City pride, and then we started back down. Again, I did my best not to look down at the vast, dark, unprotected expanse leading to a tiny oculus of light below, where I spotted Jakubovich awaiting us before I started to clamber down.

Back in the shadow of the bell, my thighs felt like I just went for my first long-distance run in a decade, and I was light-headed from the adrenaline. But I couldn't wait to get my kids so I could show them the pictures I'd taken.

On the Wings of the Milwaukee Art Museum's Brise Soleil

D o you want to climb the wings?" Milwaukee Art Museum public relations manager Kristin Settle asked as we walked toward a gallery to tour a new exhibit. Even if the museum's brise soleil is about the least hidden thing in town, how could I say no?

A couple weeks later, on a day the museum was closed, I met Settle and MAM facility engineer Dan Kehrer in Windhover Hall. They informed me that I was the first writer—and second member of the media world—to make the climb, and we set off.

In the interim, I had asked Settle how we would get up to the wings, and she was coy. "You'll have to wait and see," she said. The morning of my visit she wrote in an e-mail, "Bring your courage." I had no idea what to expect. Would we climb with ropes? From the public spaces, it's hard to imagine that there's an interior path to the top.

But architect Santiago Calatrava is a talented fella. He most certainly did build in an interior route to the roof, and it is from that that we visited the peak of the mast that holds the museum's moveable brise soleil.

The brise soleil (or sun shade) has seventy-two steel fins that open and close with the museum and daily at noon. The shortest are at the bottom at 26 feet long, but the longest ones, at the top, reach a span of 105 feet. The ninety-ton brise soleil's 217-foot wingspan is similar to the wingspan of a Boeing 747-400.

The climb begins in an extremely unprepossessing location in the museum, where no one would ever expect it to be. Inside a door there's

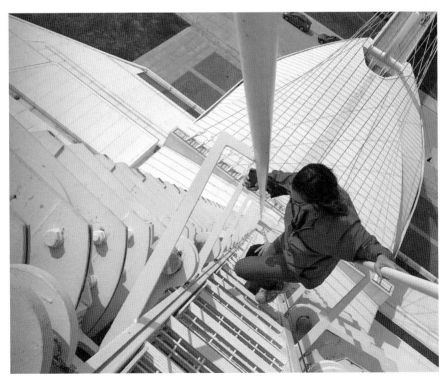

a red vertical ladder, twelve or fifteen feet tall, with rebar steps leading to a small metal grate platform. Up another short ladder and then yet another short ladder, and you're up above the ceiling of the museum, in a crawlspace.

Here in a room is the motor, control panel and a backup generator to open and close the wings that are basically directly above us. Another control panel is located in a much easier-to-access location within the museum, and that's the one that Kehrer uses regularly.

Settle pointed out a small motor that could be seen in the crawlspace off the path we were taking, saying that it is the motor that spins the giant Calder mobile just inside the museum entrance below.

Around a corridor, into a small room and up another short ladder, Kehrer pulled open the vertical roof hatch, which we crawled through. Still on hands and knees, we passed through a very short tunnel (maybe three feet long), and then we were out in broad daylight at the base of the wings.

Around us, the giant mast cables were anchored, and the lowest wings and their connections were at head level. Kehrer lifted open the lower section of the white metal staircase that rose on the axis between the wings, and we crawled through. Behind us was the Milwaukee skyline, in front of us the roughly seventy-five stairs to the top of the wings.

I set off for the top with Settle, who was making her third trip, and Kehrer, who said he gets up to the roof maybe ten times a year, typically for minor maintenance and repairs and for inspections.

There was a breeze blowing, and it was sunny with temperatures in the midseventies. I couldn't imagine a more glorious time to be up here. I reached the top of the stairs and had a clear view all around, but most exciting was gazing straight up to the point of Santiago Calatrava's Milwaukee masterwork.

Opposite, top: Sworn to secrecy, I cannot divulge how one begins the ascent to the wings that form architect Santiago Calatrava's brise soleil, or sun shade. But I can tell you that this unassuming ladder, which is the first step, is behind an equally anonymous door.

Opposite, bottom: Though it's not immediately obvious from below, there is an access staircase that rises between the brise soleil's wings. There is a handrail, too, but the climber still feels a little exposed and edgy.

I turned, sat on the top step and snapped some photos before simply breathing in the great weather and view: Discovery World and Harbor House to my far left; the Hoan Bridge; off in the distance, the Allen-Bradley Clock Tower; almost literally at, my feet, downtown, shimmering in the sunlight.

To the right was the Gold Coast of Prospect Avenue up to St. Mary's Hill, and just below, there was a worker pressure-washing the skylight windows that run the length of the Quadracci Pavilion all the way back to the War Memorial Center.

Behind me, there was nothing but blue water, planes descending toward Mitchell International and seagulls squealing their calls into the wind.

I've seen some breathtaking views of Milwaukee, but this little seat at the top of Milwaukee was hard to beat.

Afterward, we took a little walk around the roof, and Settle invited me to return on a day when the museum is open so I can climb again with the wings open. I think I'll take her up on it.

4

Sailing Out to Milwaukee Breakwater Lighthouse

Do you ever wonder what it was like for the men who landed on the moon to stand on the cratered surface and look back at the Earth, to be the only folks alive to know the feeling of being out at a place that everyone can see but that no one gets to visit and look back from?

I imagine it's much like a visit to the breakwater lighthouse felt—though obviously to the nth degree—on a recent trip out there on a Coast Guard Aids to Navigation boat.

The lighthouse, with its five-story tower, is visible at the harbor entrance on the tip of the northern swoop of the four-mile breakwater that protects Milwaukee's harbor, and most everyone in Milwaukee has seen it from Summerfest, from atop the Hoan Bridge, from an office in a downtown building, from Veteran's Park or out a Prospect Avenue condo window.

But very few have actually had the opportunity to stand atop its concrete foundation or peer out at the skyline from the top of its tower. So of course, I had to try.

Though the Art Deco lighthouse, built in 1926 and automated forty years later, is off-limits to the public, it is among the many lighthouses of which the federal government is attempting to divest itself, which is what made a visit possible. So Jon Grob, BOSN3 of the Waterways Management and Aids to Navigation division of the U.S. Coast Guard's Sector Lake Michigan—of which the Bay View station is headquarters—worked his magic and made it happen.

The lighthouse was deemed excess property in 2011, and as has been happening all around the Great Lakes, the government is trying to ink a long-term lease for the place, which was added to the National Register of Historic Places in September 2011.

"It's a long-term lease," Grob told me as we waited for a boat out behind the Bay View Coast Guard station. "It's like a ten-year lease, and it comes up for renewal. And then they have to maintain insurance. It's a long process." He also says it's a complicated process:

We still work on forty-two (lighthouses) and almost all of those have been divested. We're trying to divest this one here, too. It's been advertised. It is [difficult] *because it's big,* [and] *it's very expensive to keep it up—painting, maintenance, changing out windows. Because they're all historic, it's very expensive. You have to match the same kind. The state historic preservation offices have a say in what we can do. We can't just go on a lighthouse, even if it's completely owned by the government, and change stuff. To put a solar panel on it, we need permission.*

You'd think nobody would want to take it on. After all, there is no way to get to the lighthouse other than by boat. And when we arrived, it was clear that even that mode of transportation isn't without hurdles.

While the ten- or fifteen-minute ride out there is pleasant—despite the storm that rolled in bringing wind and rain—and offers great views of the city, there is no dock at the lighthouse. You have to pull up alongside and climb a metal ladder up the side of the foundation. The water around the lighthouse gets pretty choppy, so the boat is bobbing pretty good in the drink. I'd have been leery about if I wasn't with a half dozen Coast Guard personnel.

"If somebody wanted to make a museum out of it," said Grob of potential uses for the lighthouse, "or if a group of people got together and said, 'We love this lighthouse,' and they form Lovers of the Milwaukee Lighthouse—like they did in Wind Point. They have a beautiful lighthouse there, and they have a group of people that maintain it and keep it up. And the government [gave] them a deed, and on the deed, it specifies, 'You shall make this accessible to the public or make this a museum.'"

In September 2013, Optima Enrichment—a Milwaukee-area philanthropic group that helps fund camps and college campus visits for low-income kids, as well as Honor Flights for veterans—bought the lighthouse. The group plans to raise a projected $2.5 million to

restore the lighthouse and open it to the public for tourism, events and meeting purposes.

When we arrived at the base of the lighthouse—the breakwater is owned by the Army Corps of Engineers, though the lighthouse itself is administered by the Coast Guard—a couple sailors climbed the ladder and went around to open a door in the foundation from the inside, saving the rest of us the roughly fifteen-foot climb up.

Once through the door, we were in the base on which the lighthouse sits. It was dark in this space, which has four or five smallish rooms that likely served as the offices and perhaps storage. There are some windows here, but most are sealed up.

When we walked in, the Coast Guard personnel, who visit the place at least once a year, were surprised to see a plaster ceiling had fallen. This crew knows the lighthouses pretty well, according to Grob.

"I've [only] been out there maybe three times [in five years]," he said. "These guys work them every year. They have to go out and physically inspect them. They check the wiring, the lights and the sound signal. They have specific testing they have to do. If there are batteries, they have to do load testing on the batteries. Whatever the cycle of inspection required, that's what they'll do."

He made a note of the damage so it could be reported to the engineering and repairs departments before we headed upstairs.

The main part of the lighthouse has two stories with four to six rooms on each floor. On the first floor is a kitchen, living room, dining room and a boat room, with a big "garage door" that opened to pull a boat in. On the second floor are four bedrooms, a bathroom and some closets. Other than some plumbing—and walls and floors, of course—almost nothing remains of the rooms.

There's plenty of space in the structure, but it's not in very good shape on the inside. Plaster has fallen from spots in the ceilings and walls, and the floors—most likely hardwood later layered with tiles from what we could see—have been almost entirely removed, though subfloors remain.

"Not that long ago, maybe twenty-five to thirty years ago, we had people living in them, maintaining them," Grob said. "I knew a guy that he and his family, that was his job. He was active-duty Coast Guard, and he lived in the lighthouse and took care of it…put gas in the generators and made sure the light was going.

He continued: "In Racine, they used to have a big lighthouse. It's the neatest one I've ever seen. It looked like an old Tim Burton movie

lighthouse. They used to bring guys out there, and they'd stay. There were times they couldn't get to them because of weather, and in the winter, it freezes."

There's no power these days, and according to a logbook we discovered just below the light in the square, two-story tower, the lighthouse was converted to solar power on October 16, 2008. The light and the foghorn are run off solar panels that sit out on the third-story deck, facing out toward the lake.

While things look rough inside, the guts of the lighthouse look like they'll easily make another couple hundred years. The house itself is riveted steel atop a massive concrete foundation resting on a concrete slab that sits on three reinforced concrete caissons. It's not going anywhere.

At the tip-top, of course, is the red light you can see every night. There's also a NOAA weather station on the lighthouse, and just outside the circular space containing the light is the foghorn, which, believe it or not, isn't controlled by the Coast Guard, but by boaters out on the lake, who can use their radios to activate it and warn other craft of fog.

I remember my days living on the East Side, lying in bed in summer listening to the throaty groan of the foghorn. Despite its unassuming visual aspect, seeing it was one of the highlights of the trip for me.

Needless to say, the views of the Milwaukee skyline are pretty dramatic from the lighthouse. But so is the view to the east, where Lake Michigan sprawls out as far as the eye can see to the north, east and south. It's a serene, yet powerful landscape.

Maybe the views were part of the draw that got this place divested. Because while there was none of the bats or other wildlife I'd been warned to expect, the place was pretty rough inside (and don't forget the trip).

"There was quite a bit of maintenance we did before we divested them," Grob says of other lighthouses. "Now they have them officially under deed. They're going to make them just absolutely phenomenal... Lighthouses are wonderful. They really are. They're so historic to the lakes because they were so important to the shipping. And they go back, and they're all unique. Very few, if any around here, are the same."

Standing on the Shores
of Lake Emily

After months of trying to gain access, I have finally stood on the shore of downtown Milwaukee's Lake Emily and gazed out on its limpid waters. But it turns out, I arrived overprepared and could have left the swimsuit and sand toys at home.

Let's go back in time for a moment to when settlers arrived in what we call Milwaukee, more specifically, the area around Wisconsin Avenue, Mason Street, Van Buren Street and the lake. Much of the area now called East Town was a swamp, with anywhere from two to six feet of water, depending on where you stood.

Wisconsin Avenue, before being filled in, was a narrow valley that drained into the lake. Where Northwestern Mutual's headquarters stand, there was a small body of water called Lake Emily (aka Drum's Hollow). Whether Emily was really a lake or more a retention pond created by filling in Wisconsin Avenue seems to be open to debate and opinion, and the facts are, for now, lost to history.

Regardless, despite the comings and goings of downtown development and the now century-old NML headquarters built right on top, Lake Emily has never gone away. It's still there, alive and well, according to Scott Wollenzien, NML's facility manager, who describes Lake Emily as "a depression with water that probably wasn't very deep…I would imagine that this little lake froze out every year. Six feet is probably the maximum, at its deepest point. Lake Emily was a natural retention pond. People used to bring their horses down here to water them, and kids used to swim in it."

Hearing that, I arrived at NML's stately and imposing 1912–14 headquarters (designed by Chicago architectural firm Marshall & Fox) at 720 East Wisconsin Avenue—with sunscreen, of course—to meet Wollenzien and get a peek at Lake Emily.

Wollenzien explained:

> They had to dewater this area in order to build the building…They dredged it out…This building went up in 1912. It took over seven years to build, so back about 1905, it was first started. They had to, first, drain the land, then they dug out the land using steam shovels.
>
> The building's built on wood pilings. Each one of those pilings is about sixty-five feet long, and they're virgin timbers from the northern part of the state. They brought them out via horse and buggy and floated them down Lake Michigan and then hauled them out of the lake, nearby.
>
> They drove the pilings in and then started to build on top of them. Each piling was numbered and grouped before being capped and built on top of. A lot of concrete was used to cap pilings back in those days. The pilings were also tested to make sure they were down to bedrock and a special gauge was used.

Twenty years later, a major eight-story addition was put on the north end of the property. The 1932 building was razed in 1978, but its footprint covered the current atrium and ran straight up to the sidewalk along Van Buren, Cass and Mason Streets. The same process had to be repeated.

"They had to dig out the area about twenty feet first, and that's where they started driving their piles. They drove those pilings down to bedrock—there are three thousand of those individual pilings underneath the original building," said Wollenzein.

"There are four thousand pilings underneath the second part of the building. The reason that there's a difference is because this [extant] building was always meant to be eight stories—and it still is today—and the old north building was meant to be up to sixteen stories, originally eight, with the opportunity to build eight more on top," he continued.

Though you can no longer see the north building above ground, its basement and sub-basement survive and are used for storage, workshops, a bakery and other purposes.

The walls here are insanely thick—four feet nine inches!—and consequently the basement of a building that no longer exists could be

one of the safest places to be in downtown Milwaukee in the event of something like a tornado or air raid.

And there's "Little Egypt," a sweeping double staircase that used to offer entry to the north building from an open courtyard. These days, it sits, rather eerily, in a remarkable state of preservation beneath the northern edge of the atrium, where it abuts an air intake plenum that was built when the north building came down in 1978.

"They call it 'Little Egypt' because of the architecture of the staircase," said Wollenzien. "It's a grand staircase, and you used to be able to walk down to an outside garden and walk back into that level, as well. We're standing underneath the skywalk. These large columns that you see on the side here are holding up the skywalk. We're twenty feet or so below grade."

But I came to see Lake Emily. I had brought a rubber ducky and wanted to float it.

Wollenzien understood drama. As we walked through the brightly lit basement, workers wandered past, engaged in all manner of maintenance tasks. Wollenzien told me a bit about his crew and what they do.

"We have a team of fourteen mechanical engineers [who] manage the downtown campus; we have fourteen mechanical electricians—these are all full-time associates; and we have three full-time technicians that help support the campus six days a week," he said.

He went on to detail their work:

> We have about a million and a half square feet of office space that we help maintain. We have lots of pipes and mechanicals. What we've done over time is to monitor the wood pilings and take care of them, always keeping them watered or wet to keep away the oxygen.
>
> We monitor the water through seventy-four holes underneath the building. Years ago, we used to do this with a large measuring stick to measure the height of the water, and we wrote it down on a piece of paper. We like to make sure that there's water at the bottom of at least every hole. If you don't see water, then it's a problem. As long as you can see the water, it's covering the pilings, because they're below the bottom of the pipe.
>
> We used to water each of these seventy-four holes with a garden hose. That was never really enough water to keep the system charged the way it should've been. What we do today—we just started doing this three years ago—we have to test our sprinkler system every week, so when we

do test them, instead of just throwing the water away down the drain, we throw it underneath the building…keeping that system charged. It's about five thousand gallons a week.

Notching up the anticipation, Wollenzien stopped at what I thought was a random spot in the basement of the old north building. In the next room was the sprinkler system he had described a moment ago. As we stood in this right of way, with people wandering past, he recalled when he first heard of Lake Emily:

"When I was a new employee here ten years ago, I went through orientation, and they told me about Lake Emily, as well. And the first thing you picture in your mind is, 'Do I really go downstairs and open a door, and there's a lake? Kind of strange.' When we actually came down here and took the tour, we found out that Lake Emily is really underneath the building—underneath the nine feet of floor in this building."

Wollenzien bent down, pulled the cap off what appears to be a floor drain and told me to look. The light caught just right, and I saw a small glimmer of water at the bottom.

"That's Lake Emily," he said. "Lake Emily today can only be viewed through one of seventy-four observation holes. The water is above the pilings about two feet, and about nine feet below the floor."

He pointed out that there are similar caps running every few yards along the basement floor. Each offers a tiny glimpse at our hidden Emily. These days, he said, they don't monitor the holes with a stick anymore. It is now done electronically with a probe that records the level.

"We can see over time where it raises and lowers," Wollenzien says. "We do several holes on a monthly to quarterly basis. We can add water to this corner, which is the southeast corner, and we can have water migrate all the way to the northwest corner just by gravity. So when they built this building, the engineers had this in mind. They also directed all of the rainwater from the roof down into that system below. We're not trying to defeat Lake Emily; we're trying to preserve her."

Wollenzien must have sensed some disappointment, or anticlimax, in my expression because he said, "Let's go" and was off down the hall. We stopped to see the pipe run—a passage a few feet wide that runs the perimeter of the foundation, allowing for pipes to follow a straight path without clogging up more trafficked spaces—and we stopped again at what seemed like a random spot, though I admit I ought to have known better by then.

Admittedly, this doesn't look like much, but beneath caps like this one, which is in the sub-basement of the Northwestern Mutual Life building, are the wood pilings that support the massive classical structure. They help keep it from sinking into the muck of the pond that was once called Lake Emily.

Lifting a metal door in the floor that's maybe two and a half feet long and eighteen inches wide, Wollenzien said, "We won't go far, but this is the sub-basement. Not many people have heard of this." And he pointed the way down. So down I went into a space that's maybe four feet high. It's lighted, but fairly dimly.

We were surrounded by concrete. The walls and floors were all cement. Every few yards there was a tiered pile of progressively narrower concrete blocks, the biggest probably four feet by four feet square, maybe two feet tall. Wollenzien explained the view:

> *What you're looking at are the pile caps. It's like a two-tiered cake. It's huge. Each one of these pile caps is grouping the wood pilings together, and this is what helps support the building. This is one of the areas that we're actually looking at for testing of the wood piles to determine what their capacity is underneath the building for the new construction* [of an office tower to the east].

We have various engineers studying that as we work through our new construction planning project. It's something that we're closely monitoring and wanting to be aware of. I don't think it's been decided yet if we're going to use the pilings or not.

This is a cool area—not many people get to come down here. The floor here is about four feet thick, and some of these I like to call a layer of cake. There are three, sometimes four layers that you can see. It's just a massive structure that's holding this building up.

There are some observation holes and pipes like the ones we saw upstairs. But we are now four or five feet lower down.

"This," said Wollenzien, "is as close as you can get to Lake Emily."

6

Behind the Scenes: The Domes

If you visit the Domes fairly regularly with some inquisitive little minds, as I do, you'll have found yourself stumped by a number of questions. Armed with some of those questions, I got a behind the scenes tour of the Mitchell Park Horticultural Conservatory, better known to all Milwaukeeans as the Domes.

Designed by architect Donald Grieb, the Domes were constructed in stages in the 1960s, based on the geodesic dome designed by architect Buckminster Fuller. They replaced a long-lived "crystal palace"-style conservatory that stood on the site for many years.

The show dome (the one to the north) was erected first, in December 1964. The tropical dome (south) followed in February 1966, and in November 1967, the trio was completed when the arid dome (east) opened. Since then, the Domes have become an integral part of Milwaukee's image, both at home and beyond.

But despite their obvious landmark status here, by the 1980s, the Domes were in trouble. In more recent years, that decline in attendance led to a conservatory that looked tired and needed a jolt. Former parks director Sue Black provided that jolt by hiring Sandy Folaron as director. Now, the Domes have changed more in the past five years than they had in two decades before that.

"I think because the writing was on the wall," said Folaron in her office that was formerly a storage closet. "Maybe it worked in the '60s, maybe in the '70s. But in the '80s, there was a huge drop-off in the

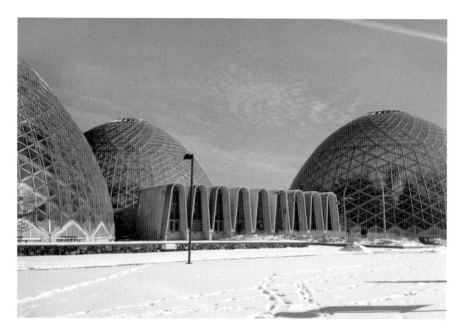

Designed by Donald Grieb and based on the geodesic dome created by Buckminster Fuller, the Mitchell Park Horticultural Conservatory, better known as the Domes, is one of Milwaukee's most recognizable landmarks. But few get to go behind the scenes.

number of people coming here. They weren't supporting the facility as much as they used to. People are pretty extraordinary at designing and maintaining their own gardens and having access to things that before were the draw here."

Folaron came in and likely upset some apple carts as she decided that anything was ripe for change. She remodeled the lobby, giving it a fresh, airy feel. She moved the gift shop up near the entrance into what used to be the office. She raised private money to install an alluring light show. She got savvy about using events like Music under Glass and a range of winter ethnic festivals to draw in new audiences.

On the day of my tour, in the middle of a Thursday, the Domes were packed. There were the stereotypical Domes-goers of the past—older folks— but there were tons of families with little kids, too. The place was alive.

Connecting me with horticulturalist in charge Amy Thurner, tropical dome horticulturalist Patrick Kehoe and arid dome horticulturalist in charge Marian French, Folaron promised me a look into every nook and cranny of the Domes, and that's what I got.

We started out in the tropical dome, where I immediately asked, "What's under the Domes?" I wanted to know if the roots of the myriad species of plants in this humid space dug deep down into the earth or if there were a layer of concrete below. It turns out, there isn't.

"We believe there is no concrete floor," said Kehoe. "But there is a network, like a spider web, of drain tiles that will take the water and run it off into drains that are in the pit [that] surrounds the perimeter of the dome."

Though pruning is a big job, the main day-to-day task for the horticulturalists is watering, especially in the tropical dome, which gets watered 365 days a year, Kehoe said.

"The watering is all done by hand," said Kehoe. "If you had all the same plants growing, you could have an automated system. [But] every plant is different. Not every plant gets watered the same every day."

Two people do the watering. Each takes a part of the dome so there's no confusion about what has been watered and when.

If you wander through the Domes, you would be hard pressed to see any hints of infrastructure. That's because it's all hidden away in a crawl space and in what is called "the pit." Each dome has a recessed area running around its perimeter that affords access to any spot. Additionally, moisture that collects on the inside of the dome drains along channels in the web of window frames and ends up in the pit, where it drains out.

In addition to the horticulturalists, there is a person at the Domes who is in charge of tending to the birds that make their homes in the arid and tropical domes. This person feeds the birds and is tasked with catching and releasing rogue birds that manage to get into the Domes through the loading dock and other connections to the outside.

Infrastructure and birds are interesting, but what I really wanted to know was if the horticulturists ate the fruit of the plants in the tropical dome.

"I just picked some coffee beans today," French said. She's been trying her hand at roasting them properly. She also has attempted to make chocolate from the beans in the cocoa pods, with zero success so far.

Kehoe then plucked an ambarella fruit and sliced it open for me to try. It was juicy and fleshy and tasted something like a mix between a lemon and a persimmon. It was my first taste of Domes fruit, but not my last. As we walked on, discussing soursop, yellow guavas and the avocado tree that's no longer there, the conversation turned to bananas.

"Do you eat the bananas?" I asked Kehoe.

"We do, and they're delicious," he said. "We just happen to have a plant that has ripe bananas on it now if you'd like to try it."

We walked back behind the gate, and Kehoe scaled a ladder above the pit and cut down a handful of bananas, which he gave to me to try and bring home to share with my family.

They were small, but sweet and tasty. The latter is not true of all the fruit growing in the Domes, however. The plants grown in the Domes are not hybrids created for human consumption, said Folaron.

"It isn't the kind of fruit that you find at Pick 'N Save. It's not grown to be eaten [or] to really be something that American palates are used to," she said. "So we may think, 'Oh there's so much membrane in this.' Because it's a natural environment, too, we might just open up a grapefruit and find an insect in it."

But the fruit is most definitely edible.

"If there was an Armageddon, that would be the dome to go to," Folaron quipped of the tropical dome. "That's the dome where you could best survive, rather than the other two."

Speaking of the other two, we took a pretty quick look at the show dome, which was the most popular that day because the annual train show was taking place and it drew many eager onlookers, especially ones under the age of ten.

"The show dome is a whole 'nother animal in itself," said Folaron. "Mary Braunreiter designs those layouts. We grow those things for her. They're installed by the forestry department. People from all across the county come to help up install those shows. So as much as I hate that 'It takes a village' [maxim], it really takes a county to get those shows on."

We then spent a little more time strolling the arid dome, where French works her magic. In there, she's been working to freshen up exhibits and replace tired plantings with exciting new geographically themed areas. A lot of pruning has helped spawn growth by allowing plants more access to sunlight.

Next, we checked out the dome-ish transition greenhouse, where the behind-the-scenes horticulture work takes place. There were also greenhouses out at the county grounds with two full-time horticulturalists, but when I visited, work was underway to build replacements for them right behind the Domes. The new greenhouses—completed in late 2013—will make things a lot easier for staff, saving transportation time and loosening limits on the size of plants that can be grown in the greenhouses.

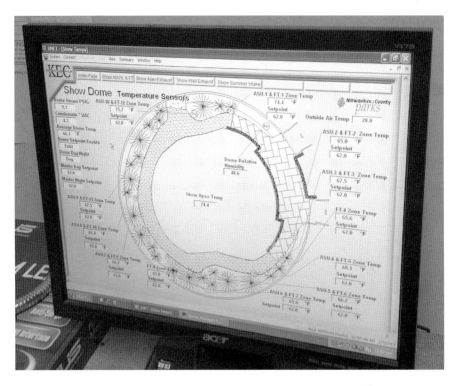

In the past, it took a number of large control panels to regulate the lights, temperature and other aspects of the domes' atmospheres. Today, most everything is regulated and monitored by this one computer adjacent to the Show Dome.

Attached to the transition greenhouse is an orchid room, where sensitive orchids are nurtured and where the horticulturalists test out ideas and carry out experiments.

Next, we went underground through the massive boiler room, which houses four huge boilers, and past the giant tanks that hold water (for the plants) and a mix of water and fertilizer and into what looks like the most organized basement you've ever seen. Here, rows and rows of shelving hold props to celebrate every holiday you can think of.

Finally, back upstairs, we took a look at the small but powerful system that controls the light show and the old heating control panel before peeking in at the computer that now runs the systems in the Domes. On the screen, we could see temperature measurements for just about every spot in all three domes. The automated system makes sure the plants are kept in appropriate conditions at all times.

And as much as Milwaukeeans love the events and the light show and everything else, the Domes are still really about the plants.

"I'm hoping the new greenhouse will allow us to do more hands-on stuff with the kids," Folaron said. "About twenty thousand kids come here for tours every year, and that's just kids that come in a classroom situation. Education is a huge element here. That's our core mission… The Domes are not just about the grandmas anymore."

Signing My Name atop the Dome of the Basilica of St. Josaphat

The question: Do you want to visit the top of the Basilica of St. Josaphat dome?

The reply: Sure, I do.

Before the visit, I envisioned previous jaunts to the tops of various buildings, including soaring church domes in Europe. There would be a lot of steps to climb. There would, as always with these nonpublic offers, be a waiver to sign.

For the first time in my professional career, however, I found a waiver that really seemed necessary. The climb to the cupola of the dome on the corner of Sixth Street and Lincoln Avenue, roughly 225 feet above terra firma, is, quite literally, a climb.

A church was first built on the corner of Sixth and Lincoln in 1888, but it was destroyed by fire in its first year of life. By 1901, built from materials salvaged from the demolished Chicago Post Office and Customs House—and transported north on five hundred flatbed train cars—the Basilica of St. Josaphat, designed by architect Erhard Brielmaier, had been completed.

In 1926, Italian artist Gonippo Raggi helped complete the decoration of the church's interior, and three years later, Pope Pius XI declared St. Josaphat a basilica, making it the third in the United States.

The offer to ascend to the top of Milwaukee's most beautiful dome (sorry Mitchell Park) came as St. Josaphat was in the midst of a capital campaign, which is still ongoing as of this writing.

In the 1990s, the dome and the interior were completely refurbished and continuing maintenance work has forced the South Side Roman Catholic congregation, which draws membership from across the Milwaukee area, to be in a constant fundraising mode.

A few years ago, the Fotsch family made the largest-ever donation to St. Josaphat. In honor of their departed patriarch, William, the family gave about three-quarters of a million dollars with the caveat that the cash be used to air-condition the church. While the congregation was thrilled by the gift and by the prospect of finally getting some relief from brutal summer heat, the building itself remains a hungry beast.

"The foundation is eternally grateful to the Fotsch family for making our distant dream of air-conditioning a reality," said Susan Rabe, the executive director of the St. Josaphat Basilica Foundation, on the day I got a tour. "We still need to raise $800,000 for our Lighting the Way campaign to complete interior lighting upgrades, add exterior lighting in the portico and bell towers, restore the sacristy and stairwell stained-glass windows, restore exterior masonry and improve the sound system. We hope the Fotsch family gift inspires others in our community to help us complete our important preservation and restoration projects."

In the autumn of 2013, the foundation had raised enough to embark on some of the exterior lighting upgrades, moving ahead on a plan to illuminate the bell towers, visitors' pavilion and portico, but lighting of the dome will have to wait, for now.

It was Rabe's smiling face that greeted us when we—I was joined by my photographer Molly Snyder and Colin Hutt, who helped set up the visit—arrived for our climb. She, however, resisted the urge to go up to the top herself, instead connecting us with a guide (we were asked not to use his name), who was charming and had a great sense of humor.

As we ascended a few flights of a typical church staircase—wide, with tall ceilings and fairly decorative—the guide wondered if our shoes would be appropriate to the task ahead, which was the first thing that made us mentally say, "Hmmm."

Then we climbed a steep wooden staircase (the likes of which I'd already encountered on visits to the attics of old schools) that led to an interior room in the bell tower, which had some mechanical workings for the bell system. Here, our guide said that as we went up higher, it would become very dark. Maybe, he said, he should have brought up a flashlight. Hmmm.

You can see the dome of the Basilica of St. Josaphat from points far and wide across the city. But the best view is to be had from the adjacent belfry. Just be sure to be conscious of the time or you'll get an earful when the bells peal.

Another steep wooden ladder took us out in the open air of the bell tower. Actually, we got up there at 2:13 p.m. and decided to wait inside a few minutes to see if the bells would ring at fifteen minutes past the hour. They did not, so we went out. Then, the bells rang. Luckily, it was the two o'clock hour and not noon.

The views of the South Side were nice—and those of downtown would likely have been great, too, on a less foggy, overcast day—from the bell tower. We also got a stunning up-close look at the exterior of the dome, topped with the cupola we would soon visit. It didn't look very high from here.

Going back inside, our guide slid shut the heavy wooden door giving access to the bells and said, "Maybe I should go first. If you see bats up here—there are a lot of bats up here—cover your hair. They'll go for your hair." Hmmm.

We ascended another steep wooden staircase and climbed over the top of the sanctuary to visit the matching tower on the west side of the façade. There were no bells here, but as the Sherpa pointed out, there was lots of guano. Heading back in, he added, "There's no need to visit the room below this space. There's nothing in there but an old guitar, and it's out of tune."

"Have you tried to play it?" I asked.

"Oh yes, and it's very, very out of tune."

To get to the dome, we then needed to traverse the length of the nave—above the ceiling, of course, along a plank path in near total

darkness. At the far end, we reached the northern side of the dome and crawled through a small doorway into a narrow space that circles the dome itself. On one side was the exterior wall of the dome. On the other, with holes cut into it for access—and affording head-spinning views of the church perhaps 180 feet below—was the ceiling of the dome.

Here, we began to wonder if we wanted to go any farther. Our guide explained that in the past, workers changed light bulbs in the dome by crawling out the small hole and standing on a ledge barely a foot wide.

"They'd keep their backs to the wall," he said. Um, I thought, no way.

Climbing between steel support girders, he approached a vertical wooden ladder—certainly as old as the building itself—that extended up into darkness. We couldn't tell how tall the ladder was.

"We should probably go up one at a time," he said. "I'm not sure the ladder can hold more than one of us." Hmmm.

We expressed concern about going higher until we could see how high the ladder went. When we saw the guide's feet disappear perhaps twelve to fifteen feet up, we decided to go for it, one at a time. An identical ladder followed, leading us to the base of the curvature of the dome. There, we went up a staircase/ladder that followed the arc of the dome.

Once at the top, our Sherpa left the staircase and removed a heavy circle about the diameter of a car tire, opening up the oculus, so that we could peer straight down, two hundred or so feet, straight to the floor of the church below. It was a disconcerting feeling to be in a dark, dangerous place—that may or may not have been inhabited by bats—gazing down into one of the most gorgeous interiors in the city.

Another staircase and another vertical ladder (this one obscured by metal beams requiring us to go up sideways) led us to the cupola, with a 360-degree view of the city. The small space, with windows all around, was covered with the signatures of visitors from across the decades. We even found one dated "'01" that was carved into a two-by-four and was clearly more than eleven years old.

Our guide suggested we add our names, and we obliged before heading back down. The descent felt, to me, considerably more nerve-wracking than the climb. In the darkness, moving backward down the steep wooden staircases and ladders was slow, sometimes challenging work.

When I reached the bottom, I had a mild feeling of anxiety, mixed with the dissipation of excess adrenaline, and a sense of satisfaction, which only increased when the guide told me that, on a visit perhaps a

decade ago, the fire inspector reached the foot of the first vertical ladder and declined to go any farther.

While the ends certainly justified the means on the trek up to see Milwaukee from the dome of the Basilica of St. Josaphat, thinking about it the next day, I decided that the means were really the most interesting part. Let's face it: you can get a decent view of Milwaukee from a few vantage points, but getting to the top of dome was just about the most challenging behind-the-scenes journey I've taken.

Tiffany Windows Shine a Light on St. Paul's Beauty

As an inveterate traveler and art fiend, I find myself wandering around a lot of churches—that is, everywhere except in Milwaukee.

The first stop on what may or may not become a tour of Milwaukee's historic and artistically significant houses of worship was St. Paul's Episcopal Church, which is notable for a number of reasons. The parish, founded in 1838, is the city's oldest, and the current church was built of dark red Lake Superior sandstone in 1884 on the Richardsonian Romanesque Revival designs of Brew City architect Edward Townsend Mix. If that's not enough, some of the ironwork at the church was created by Milwaukee iron artist Cyril Colnik. But many people treasure St. Paul's for its stained-glass windows. The church boasts the largest collection of Tiffany Studios glass in Wisconsin. Of seventeen windows in the nave and transept, including the magnificent rose window, eleven (or maybe ten, more on that later) are by Tiffany, and they are stunning.

St. Paul's has a small printed guide that notes that the church's collection of Tiffany glass is the result of the chain of relationships between Milwaukee's T.A. Chapman Department Store and Tiffany Studios and between parishioners the Miller family and Chapman's. The booklet offers a guided tour of the windows in the sanctuary, beginning with the enormous "Christ Leaving the Praetorium." Based on a painting by Gustave Dore, this is the largest window ever made by Tiffany. Installed in 1884, it was damaged by fire in 1950, but you'd be hard pressed to notice the damage amid the lavish explosion of

St. Paul's Episcopal Church boasts not only the largest collection of Tiffany windows in Wisconsin but also the largest Tiffany window in the world.

color. The center section of this window was reproduced by Tiffany for windows in six other churches.

Just to the right is a late 1880s or early 1890s window created as a memorial to Cyrus Hawley (yes, of Hawley Road fame). This is a fun window to see up close, as portions of the glass protrude out from the surface, giving it a nice textured, three-dimensional feel.

A little farther along the east aisle is a pair of windows—an ornamental cross that is a memorial to Henrietta Colt and a wistful, purple-winged angel—that was part of the 1893 Columbian Exposition in Chicago. The angel was perhaps designed by Tiffany's Lydia Emmet, who designed works that appeared in the exposition's Women's Pavilion.

Another pair of Tiffany windows—these depicting Christ on the road to Emmaus—from 1915 follow. Of note on these is the effect of the layers of glass, the generous use of copper foil and, on the right panel, the Louis Comfort Tiffany signature that was used from 1915 on.

Across the west aisle in the nave, most of the windows are fruit of the Tiffany studio. "Christ in the Garden of Gethsemane" and the "New Jerusalem," both dated 1915, are similar in feel to the Emmaus panels and are instantly recognizable as Tiffany works thanks to their color palette and style. The "Annunciation" window that appears next is attributed to Tiffany in church documents, but experts believe the style suggests it is not Tiffany. However, two of the following three—"Star of Bethlehem" from 1894 and "Blessed Are the Pure in Heart," which is around the corner in the west transept—are Tiffany.

Before leaving, be sure to stand in the center aisle and turn toward the main entrance to see the incredible rose window, installed prior to 1890. The center section features the faces of angels, and the outer "petals" are made of pressed glass, which creates stunning light refraction when the sun is out.

Thanks to its architect, the work of Colnik and, especially, the amazing collection of Tiffany glass, St. Paul's was added to the National Register of Historic Places in 1974.

9

Unexpected Treasures
Uncovered in St. Francis

While my visit to the St. Francis complex that is home to the Sisters of St. Francis of Assisi didn't uncover any evidence of tunnels and caves on the southern end of Bay View or anything like that—not that I necessarily thought it would, mind you, but you never know!—I by no means left disappointed. In addition to getting a tour of the community, which was founded on the site in 1849, I got to meet Sister Clare Ahler OSF, who is as sweet a person as you'll meet, and lest I forget, I got to see a fragment of the veil of the Madonna—Mary, the mother of God.

Halfway through the nineteenth century, a small group of Franciscans left Ettenbeuren, a small town in Bavaria, and staked out a community in the current St. Francis, along Lake Drive, at the invitation of Archbishop J. Martin Henni. Though there have been some splits over the years—one group left for LaCrosse barely a quarter century later, and that group also split later on—the community is still active in St. Francis.

Sister Clare told me that there are roughly 225 sisters currently living in the community and that the median age is likely in the upper seventies or lower eighties. When I asked if there were any young women entering the sisterhood, Sister Clare was able to conjure the name of one in her forties and a couple more in their fifties.

The age range of its members explains why the community now has the feel of a retirement village. There was Wii bowling going on in a room that we passed on the second floor, and Sister Clare greeted a number of her fellow members who passed us in the halls in their wheelchairs.

The heavily wooded St. Francis seminary complex is located along Lake Michigan in a community that now bears the seminary's name.

But don't think for a minute that the place is a sad one. There is a lovely mural that tells the story of the community, photographs of the mothers superior along a first-floor corridor and lots of smiling faces. It is a cheery place.

I was eager to see the complex's architecture, so Sister Clare took me to see the chapel and the oldest extant building in the complex, which was built in 1861. (That building is not the Assisium, which can be seen just south of the main complex. The Assisium is an open-windowed wooden structure that re-creates the original building erected on the site in 1849.) The 1861 building is fascinating. The hardwood floors creek with age, and no one even bothered to try to hide the pipes that hang down from the hallway ceilings. In this building, there remain small the "cells" that were home to sisters for decades. They're maybe ten by seven feet and contain a bed, a small table and a window.

On the top floor is a big open room that was a dormitory. Here, the sisters didn't even have the luxury of walls. Curtains enclose a bed and a table with a basin, much like an old hospital ward. Though the space seems to lack privacy with the ten or so beds currently in it,

Sister Clare said back in the day there would have been three times as many up there.

She also said that some of the sisters still crave the serenity and simplicity of the second floor cells and occasionally occupy them for brief periods.

At the end of the hall, a former sewing room is now home to a small greeting card business run by the sisters. Adjacent to the dormitory space above, artist Sister Stella Devenuta has her studio and workspace.

This building is attached to another built in 1888, and jutting out to the north is the 1894 chapel that seats more than 250. Sister Clare, who has been in the community for well over a half century, remembers a time when Mass meant standing room only. The Gothic chapel—designed by architect Erhard Brielmaier—is 46 by 112 feet and has 30-foot pillars running the length of the aisle. The lovely stained-glass windows were imported from Innsbruck, Austria. Brielmaier, who also designed St. Josaphat Basilica, had three granddaughters in the Sisters of St. Francis of Assisi congregation.

Perhaps the most interesting of all is a pair of reliquaries at the back of the chapel. They're not large and are easily missed. Designed by Brielmaier, these reliquaries hold a couple hundred relics that were collected by Mother Thecla Thren, who was superior general from 1898 until 1930. There are relics of San Sebastian, San Fabiani and others, as well as, according to a list on the back of the reliquary door along the east wall, a piece of the veil worn by Mary, the mother of Jesus. I was momentarily at a loss for words, my skepticism tempered by awe—and vice versa. Then I read the listing to Sister Clare, who seemed a little surprised herself.

In all honesty, I wasn't sure what I expected to find when I requested a tour of the grounds, but I was pretty sure a piece of fabric belonging to the Virgin Mary was nowhere on the list. At that moment, I felt like I knew what drew me here.

Outside, after Sister Clare and I said goodbye, I took a stroll beneath the long path under the grape arbor to the west of the buildings. If the veil is a spiritual and historic touchstone hidden in plain sight in Milwaukee, the grape arbor path is one of the city's "secret" relaxation spots. Out of the sun, it was cool and a little dark, and the hustle and bustle of the city felt light-years away.

Emerging on the north end of the arbor, I could see the two buildings that are now government-subsidized housing for the elderly. Beyond that

were some smaller buildings that belong to the community and a big, open green space that Sister Clare said is being planted with native species. It is work that the Sisters of St. Francis of Assisi feel is their calling, a way to honor their patron saint and his devotion to nature and wildlife.

St. James Church and the Spring Street Burying Ground

In the low, dimly lit space beneath St. James Episcopal Church, 833 West Wisconsin Avenue, there's a hissing sound and a horizontal geyser of steam shooting out of a pipe. It immediately grabs your attention until you see the tall, thin gravestone leaning up against a brick column. St. James is built atop the former Spring Street Burying Ground. They think all the human remains were removed when the church bought the property in 1850, but a few scattered headstones mark a lingering doubt.

But let's start at the top.

St. James got its start as a mission of St. Paul's Episcopal Church with a wood-frame chapel on Second Street and Wisconsin Avenue in 1850. In 1851, the church purchased a plot of land for $150 from the City of Milwaukee on the south side of Wisconsin Avenue bounded between Eighth and Ninth Streets and moved its existing building to the site. That site was where the Spring Street Burying Ground had been established in 1838.

In his 1876 *Pioneer History of Milwaukee*, James Smith Buck wrote, "The first cemetery on the West Side was upon that block lying between Spring [Wisconsin], Sycamore [Michigan], Eighth and Ninth Streets in that portion lying west of the alley…I have helped bury quite a number there; no burials have taken place, however, for many years upon that ground, and all who were buried there have been removed."

The cemetery was renowned for its beauty, which, apparently derived at least in part from the wild roses that grew there and for the scent they produced.

In 1867, St. James built the stone church that stands today on the site. A December 31, 1872 fire nearly destroyed the church, but the tower and walls survived and are the ones that we see today. A parish house that still stands was erected behind the church in 1899.

The easternmost part of the land was sold at the turn of the century and is the site of St. James Court apartments.

Although in his *Heritage Guidebook*, Russell Zimmermann attributes St. James to architect Edward Townsend Mix, the 1990 historic designation study report drawn up by the city says it is the work of Detroit architect Gordon Lloyd (and attributes the parish house to John Moller):

> *St. James in Milwaukee was designed during the height of Lloyd's career as a Gothic Revival church architect and is closely related in design to his Central Methodist Church in Detroit, which was built in 1966–67.*
>
> *At the end of 1872, a fire gutted the newly completed building, and only the stone walls, spire, bells, north windows, and several clerestory windows remained. G.W. Lloyd's original plans were still available, and the church was reconstructed in 1873–74 using the complete plans, some of which had not been used in the first building.*

If you've never stopped to take a look at the Gothic Revival church, you should. Though the original front doors have been replaced with plain modern glass doors, the front is striking, with the three-stage tower and broach spire on the east side and slim leaded Gothic windows on either side of the entrance, above which there is the phrase, "Enter into His Courts with Praise."

I'm fond of the side elevations, where you can see single-story aisles with a clerestory above. In the clerestory are windows—six per side—commemorating the twelve disciples. On the façade are windows showing St. Andrews (Scottish congregation members like Alexander Mitchell would have settled for nothing less), St. James, St. Simon and St. John below a quatrefoil stained-glass depiction of St. Paul, in honor of the patron saint of St. James's roots at St. Paul's on the East Side.

It's hard to look closely at St. James and not see some condition problems. Pastor Drew Bunting has no illusions on that front.

"We've had some deferred maintenance over the years," said Bunting, who joined the parish in March 2013. "I'm sure you've worked with churches and seen the effects of that, and we've got some serious problems

at this point. But underneath it all is a beautiful building that has an amazing history. I had a meeting with a structural engineer last week, and his determination is that we're structurally sound."

Bunting took me inside and showed me around the sanctuary, the most immediately striking feature of which is the ceiling, with its wooden tracery. The arches separating the nave from the aisles and the white painted walls make the space feel open and airy.

In the eastern aisle, there is a pair of windows paying tribute to Thomas Smith, a member of the A.O. Smith family, who were church members. The windows have some industrial imagery, including a bellows, a draftsman's compass, a wheel and a blacksmith. Nearby are dark wood panels that also come with a story, said Bunting.

"The panels are not original," he said. "These came over from Belgium and were given to the church and installed. They're evidently [from the] sixteenth century…from a monastery. The legend is that somebody from the A.O. Smith family donated them because they bought them for their house and they didn't like them." (An earlier newspaper article about the church suggests they were meant to be installed in the A.O. Smith boardroom.)

On the same side of the aisle are two signed Tiffany windows that are instantly recognizable for their soft hues and stylized design. Farther along is a 1950s-era leaded window that, natch, has a story: "Allegedly, you could say, that star at the very top there is actually a representation of Sputnik. The points of the star are intended to be the antennae [of] the satellite, and then those little wavy lines are radio beams. The window was dated '58, and Sputnik is dated '57."

On the opposite aisle is a chapel with a fairly workaday altar bearing a crucifix, a vase of flowers and a plaque. Three wooden plaques with rows of names hang above it.

"This is a small chapel where we commemorate. We have a ministry of indigent burials. So the morgue essentially, they have remains that have not been claimed, we work with the funeral home and the cemetery to bury them," said Bunting. "There is a list of people who will come out for the burials, and we'll [have] fifteen, twenty, twenty-five people show up. Just so people have the dignity of burial, and their names are read aloud. The cemetery donates space; the city subsidizes some of it. I think it's one of the coolest things we do as a parish. To do that, actually, is such an honor."

Above us are traces of water damage. On the opposite side is some peeling paint. Bunting said that the parish is working on securing funds

from a variety of sources to help fix the many issues faced by the church, which has been on the National Register of Historic Places since 1979.

Though the parish receives some operating funds from the Diocese, it is more or less on its own when it comes to building maintenance. And it's a small church these days, with a congregation of perhaps one hundred people.

"We'll get forty to fifty [people] on Sunday morning," said Bunting. He continued to describe the congregation and the work it does:

> It's a really diverse community in a lot of ways. I think we probably have the longest tradition of being open to LGBT people, and that is still a significant part of the community. We are very oriented toward outreach and service, in addition to hosting the Gathering food program downstairs, which is not strictly a ministry of the parish, but we host them. We have something called Red Door Clothes, which is a clothing ministry that distributes clothing two Saturdays a month that we do in collaboration with Trinity Episcopal in Wauwatosa.
>
> And we have a sundries distribution program where we collect soaps and other essentials like toilet paper. In the past, the church has been open to letting people sleep on the grounds. Unfortunately, we had some liability concerns that made that impossible to continue. We try to be considerate of the neighbors.

As we talked, we climbed the stairs up to the belfry. The tower is surprisingly open and spacious inside, with stairs ascending along the walls. When we got a couple flights up, there was a ladder, which Bunting tested out gingerly—jokingly telling me his wife's phone number, just in case. At the top, he lifted off a panel, and dust and who knows what rained down on me, making me glad I had just gotten a haircut. It was easier to shake out of my close-cropped hair. Climbing through, he gave me the OK, and I followed. In the belfry, there was the usual mix of dirt, dust and bird crap but, thankfully, no sign of bats or territorial gulls. The pigeons stayed way above us while we looked at the bells. A couple still work, but most of the nine are now frozen in place. Bunting tried to free up a couple, but it'll take more than a pair of human hands to get these pealing again.

"These are all the original bells," he said. Pointing at the Marquette University dorm next door, he joked, "I've always liked the idea of giving the undergrads an early wake up call on Sunday mornings," before

The steps up to the belfry at the Gothic Revival St. James Church are dusty but flooded in colorful light thanks to stained-glass windows.

noting, "There's only one bell that has a name on it, and it was named for a ten-year-old girl who died."

We headed back downstairs and made our way up to the altar, where there are some striking silver-toned organ pipes, which complement an entire room of pipes above the altar, though nowadays the church relies on an electronic keyboard and these pipes are little more than a decorative reminder of the past.

Before I knew it, Bunting got an almost hidden door open and was walking down a steep and narrow flight of stairs. At the bottom, we turned right and climbed through an opening that was suited more to a tween than a full-sized adult.

"This is the secret passage underneath the church," said Bunting. "Well, it wasn't really secret. I spoke to a woman who grew up here. Her father was a priest here. She told me that it was a place where if you were late coming in for choir practice or a service, you could sneak in through another part of the building. That way you did not have to go through the church. It was quieter that way."

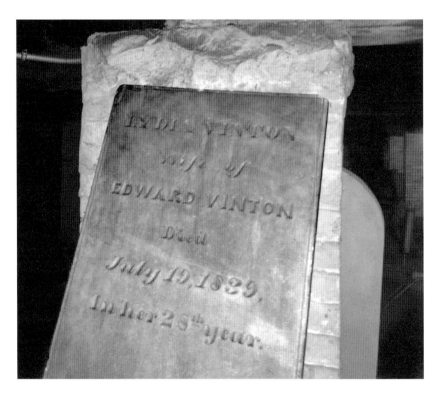

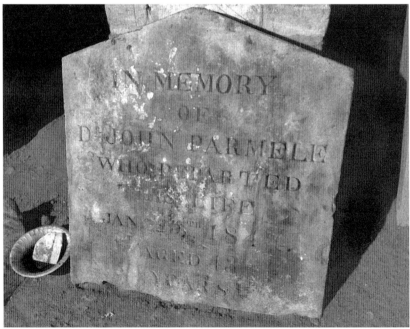

We passed some old organ parts and move into a low-ceiling area that stretches the length and width of the sanctuary above. The sound of steam—the church is on city steam—hisses at the far end of the space.

"What we call the crypt is basically the very foundation of the building, and as you saw, the church was built on the site of a former cemetery," said Bunting when we reached our destination. "The remains were all moved to Forest Home before the structure was built. But at least according to legend, and some evidence indicates [it], not all of them were…It's not like a medieval cathedral—it's not like remains are intentionally interred here. Apparently, there are remains still down here, at least some. On occasion, I've never seen it, they say that some bone will work its way up and come out of the ground."

A 1929 newspaper article said, "It is believed that the stones were discarded 68 years ago when the cemetery on the present site of the church was removed to Forest Home cemetery, according to the Rev. Charles T. Hawtrey, assistant rector of the church. The stones which have been used as a weight for the bellows of the present organ in the church probably were placed there about 30 years ago, he said."

Therefore, just because the stones remain, doesn't mean the bones remain. But no one really knows for sure. One piece of anecdotal evidence might suggest they do.

"Lydia Vinton is the ghost of St. James," said Bunting. "She sort of moves things around on you. She's one of those mischievous ghosts. I may have seen something out of the corner of my eye one time. It would have been a person walking by, but I'm pretty sure it wasn't a ghost."

Opposite, top: In the crypt—which is really just the foundation, or sub-basement, of the building—are a few tombstones left over from when this was the Spring Street Burying Ground.

Opposite, bottom: Though Dr. Parmele's tombstone is still here, his remains were likely removed when the cemetery was closed and moved to Forest Home Cemetery.

Popping In to See the Old Mitchell Place

Istill like to call it "the old Mitchell place"—jokingly, of course—but to be fair, the elaborate, historic house behind the gate at 900 East Wisconsin Avenue has been inhabited by the Wisconsin Club for far longer than by Alexander Mitchell, who built the place.

Mitchell, who was born in Scotland in 1817 and arrived in the United States twenty-two years later, was a banker—he founded Marine Bank—railroad magnate and Democratic politician who served two terms in the House of Representatives from 1871–75.

Mitchell, of course, is remembered all around Milwaukee, with a street, a park and a landmark downtown building named in his honor, as well as an airport with a name that honors his grandson General Billy Mitchell, who was influential in the creation of the U.S. Air Force.

Mitchell built the earliest part of the house—which started out humble and ended up humongous—in 1848, and as a Wisconsin Club brochure notes, the house "grew with the fortune of its owner…He gradually bought up the remaining properties on his block and expanded the house."

In 1859, Mitchell had the house updated to reflect the in vogue Italianate style, and thirteen years later, he added wings, enlarged the porch and put in window bays. In 1871, an unnamed Italian woodcarver is credited with creating the belvedere that still stands out on the lawn and that most of us would likely call a gazebo.

But much of what captures our eyes today is the work of Edward Townsend Mix, who was tapped by Mitchell in 1876 to amalgamate this

The Wisconsin Club, which began life as a much smaller home for Alexander Mitchell, has grown and changed over the years.

assortment of work into a single, grand French Second Empire mansion. Mix added the five-story tower and the mansard roof. It is Mix's building that we really see today, though if you look closely, especially outside, you can sort of see where some different Cream City brickwork meets up.

While it was sad to see Mix's Crystal Palace-ish conservatory vanished—it's been gone for more than a century now—that part of the building was replaced with a grand and elaborate ballroom, complete with a minstrels' gallery upstairs and the Mitchell room downstairs. Below, in the basement, is Alexander's, a more casual, multilevel dining room in a space that housed an eight-lane bowling alley from the 1950s until a 1994 renovation.

The conservatory housed palm trees and other plantings that were exotic in nineteenth-century Milwaukee and had a small stream running through it.

The most stunning sections of the home remain the nucleus of the old house, right in the center and off to the east. While the original main entrance, facing Ninth Street, is obscured on the exterior, inside you can still see its two beautiful stained-glass doors.

"The club is in very, very good shape," Wisconsin Club general manager John Constantine told me on a recent tour. "We've invested in this building. Since I've been here, we've put close to $23 million in this facility. I'm very proud that this facility is in outstanding shape. It will be around for a lot longer than all of us—not only the pretty carpeting but [also] the infrastructure here: the electrical wiring, the HVAC, the kitchens. All of it has been totally redone."

In what is now the main entry, you can't help but marvel at the main staircase, carved by hand over the course of seven years by a single craftsman. There are twenty-four lion heads that, I'm going to guess, reminded Mitchell of his Scottish heritage, of which he was notably proud. It was Mitchell, remember, who was responsible for ensuring that St. Andrew was among the four saints featured in stained-glass windows in the façade of St. James Episcopal Church, across the street from his mansion.

In one room there is an intricate inlaid floor. Constantine explained, "That was carpeted when we did this renovation. I pulled up the carpeting, and this is what I found. We have five different woods all inlaid. I brought a floor specialist out. He said, 'John, to replicate this floor in today's dollars—it would be a quarter of a million dollars.'"

There is so much woodwork, telework, plasterwork and general architectural eye candy in the old Mitchell place that it's hard to detail

it all. There are thirteen fireplaces. If you visit, don't neglect to look up, especially on the first floor, where there are stunningly adorned ceilings.

"The beauty of this, as you walk around as well, is back in the day, there were no electrical tools," Constantine reminded me. "Everything you see here is hand-carved, which is amazing."

The German American Deutscher Club bought the mansion from Mitchell's family eight years after Alexander died and has owned it ever since. During World War I, when America was downplaying its German heritage, it was renamed the Wisconsin Club.

The club has been remarkably successful in recent years. Constantine continued with details:

> Our membership has increased every year for the past twenty years. We've never seen a downward slide, even into '08 when the economy had problems. We have close to 1,500 members. Right now, we are in the top 5 percent of all private clubs in the country in food and beverage sales. That's how busy we are.
>
> [We] have dining. [We] have social [aspects]. [We] have many activities. We have wine dinners; we have business networking opportunities. My wife and I are taking fifty-two members to Paris in October for a trip. We're taking a group of guys out golfing in Vegas in March. We're doing one [trip] up in Napa Valley. It's just a great place to network and meet people.

In frames around the property there are bits of history—old newspaper articles, vintage photos, programs from galas—that tell the story of the building, which over the years has hosted the likes of President Theodore Roosevelt, President Grover Cleveland, President Ulysses S. Grant, Grand Duke Alexis of Russia, Prussia's Prince Henry and prominent abolitionist Julia Ward Howe, among many others.

Upstairs, we saw an array of smaller meeting rooms that started out as Mitchell family bedrooms. One has a marble fireplace, and again, each is elaborately decked out. On the top floor, there is the original ballroom, now called the MacArthur Room, which doesn't boast a lot of square footage—it's maybe fifteen by twenty-four feet—but it has an astonishingly high ceiling under that mansard.

I asked Constantine if there were any unusual places we could see, and he led us up a tight curved staircase behind what looks like a closet door. When we reached the top, we were in a space in the

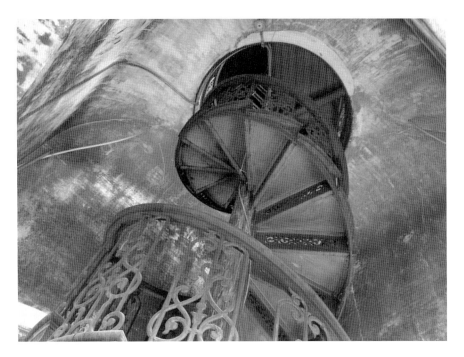

As part of a massive expansion by Edward Townsend Mix in the 1870s, the five-story tower was added to Mitchell's growing mansion. This impressive staircase curls up to the top.

tower that has a swirling wood-and-iron staircase that led up to the top of tower.

Of course, I did not hesitate to climb. At the top, I was up as far as I could go other than a nine-foot-or-so ladder that led up to the peak of the tower for flagpole access.

"Someone has to go up there and change the flag for me when it gets ripped up there," Constantine said. "Some poor guy's got to go all the way up there."

Oval windows face out all four sides, affording nice views of Calvary Church to the south and downtown to the east. There's a bit of graffiti—I found a couple dating to the 1940s—but not much. When I told Constantine, who stayed below, about this, he asked if I wrote my name. I told him I didn't, and I did not lie.

Outside, to the south was formerly lawn and is now home to a driveway, a fountain, the belvedere and some parking. I've heard talk that Mitchell had a temporary bridge built from here, over Wisconsin Avenue to St. James Church—the rebuilding of which he heavily subsidized after a devastating fire—for a wedding.

We walked over to the belvedere, and Constantine opened the door to see the inside of the belvedere, which is every bit as elaborate inside as it is outside. The walls have English tile wainscoting, a domed plaster ceiling is painted a sky blue and there is gold leaf ornament. Outside, we looked at the gingerbread scrollwork that covers the gazebo. Remarkably, the belvedere almost came down.

"That's a one-of-a-kind in this country," said Constantine. "I remember, years ago when I first got here, this thing was ready to fall down. I brought all of the members to the grass area, and I brought the president of the Milwaukee County Historical Society—Harry Anderson—and we talked about the belvedere. I said, 'Guys we have two choices. We can either come out of our pockets and fix it, or we can tear it down.' After that meeting, the members put up $100,000 in donations, and we ended up restoring it."

As we walked around, it was easy to see Constantine's passion for the Wisconsin Club, where he's worked for twenty-four years. It is, he notes, only the second job he's had in his life. He spent about twenty years working at the Western Racquet Club in Elm Grove, where he started when he was sixteen.

"I still enjoy it [when] I show people around every day," he says. "I still get excited looking at how beautiful this building is. I always see a new detail that maybe I haven't seen for a while. It's a great building for Milwaukee. I'm so proud of this place."

A Look Inside
James Douglas's Collins House

What was once the towering beacon of Prospect Avenue, the tallest structure on the city's lower East Side, is now dwarfed by a pair of condo developments just a few stories high and of arguably dubious design.

Though its tower is long gone and its towering title equally faded, the 1876 Cream City brick home, designed by James Douglas for grain broker Gilbert Collins, still stands tall at 1363 North Prospect Avenue.

That it survives is fortunate not only because it's a gorgeous nineteenth-century home by an important architect but also because it, like so many others in its neighborhood, nearly fell victim to the freeway development of the 1950s and early '60s. In this case, the house to the south—along with blocks of homes to the west—was razed in preparation for the Lakefront Freeway, but the Collins house remained. In the end, the freeway was never constructed.

The home's architect was best known in early Milwaukee as a carpenter who helped erect the old city hall, Holy Trinity Church on Fourth Street in Walker's Point and the original roof—pre-1935 fire—of St. John's Cathedral. While some have said that the neighborhood was once dubbed "Douglasville" for all the residences James Douglas designed in the area, the Collins house is one of his few surviving known works.

Though Collins had the house built, he never lived in it, perhaps because he moved to Chicago, where he was known to be living by 1881. Instead, the first occupants were Collins's daughter Ella and her husband, Edward Elwell, of Beaver Dam. They stayed about six years

Now surrounded by less-than-impressive modern construction, the Collins House is more striking than ever, even without the tower that once soared above its entrance. It's been a long time since it was the tallest structure in the area, however.

before the house was bought by a Serling, New York attorney named Alfred Levi Cary, who built an addition on the back. Cary, who had arrived in Milwaukee as early as 1859, died in 1914.

Some have said that Daniel Hoan also lived in the house, but a 1969 newspaper article noted that Cary's daughter, Mrs. Charles L. Jones, still owned—and presumably lived in—the home as late as 1938. At that time, Hoan was living in the Concordia home he occupied from 1917 until 1954.

By the 1950s, the home had become the Fenwick Club for Young Men, a rooming house, with a number of Milwaukee School of Engineering students in residence. By the early '60s, Dr. Ozzy Kowske owned the home and lived there with his wife, Gloria.

The most striking features of the home today are the two chimneys with windows smack-dab in their centers and the complex roofline that distinguished Douglas's work, earning it the name *Termes Mordax*, or "ant hill," style. But back in its earliest days, it was the home's ornate

tower (along with the also disappeared front porch) that was its most recognizable feature. With its gables and pointed spire, the tower looked straight out of a fairy tale castle. Apparently, kids who lived in the home loved climbing the fifteen-foot ladder that went up into the tower.

But lightning seemed to love the tower at least as much, and by 1938, Mrs. Jones decided it had to go. Looking at the home now, you'd never even imagine there was a tower. The only remnant is inside. On the third floor is a door that leads to a closet-sized attic space up a few steps. Here is where those kids would find their ladder. Now, it's a door and staircase to nowhere.

Kenneth Brengel now owns the home and has done a lot of work remodeling it into office space. However, Brengel also worked hard to preserve the home's character and a tour—courtesy of Bridget Brengel—around the inside reveals gorgeous details at every turn. In the basement, there are Cream City brick walls. The door at the top of the stairs must be nine feet tall. In the main entry, there is dark woodwork that is repeated throughout the building and decorative terra-cotta tiles on the floor. The dining room ceiling is open-beamed (as is the foyer ceiling), and the windows are traced in lead. A small room boasts built-ins with leaded glass windows in its doors and handsome carved details. Decorative plaster adorns walls and ceilings on the main floor, and there is a grand staircase up to the second and third floors with a supple carved banister following its curves. There are fireplaces throughout, too.

Some doors still have brass hinges, knobs and escutcheon plates. Upstairs, a bathroom has its original fixtures, including a marble sink and a giant claw-foot tub. Up here, too, is a small bedroom that some tenants say is haunted by a group of German-speaking ghosts.

One tenant said among the voices is a girl's screaming in German, perhaps related to a fire that started in the home. I haven't been able to find a record of a fire, but it's interesting to note that families that lived in the house in the nineteenth century and the first half of the twentieth all bore Yankee English names, not Teutonic ones.

On the third floor are the quirkiest features. Because of the complex roofline, a couple rooms up here are a web of wall-and-ceiling surfaces. One source claims one of the rooms has forty-nine of these surfaces, while another puts the number at sixty-five. After an attempt at a quick count, I'd deem either number potentially correct (and the numbers might be referring to different rooms).

These rooms also have the windows that peer straight through chimneys, as the fireplace flues divert around them and meet up again above the Gothic lancet windows.

It was these windows that first attracted my attention to the house, and I'm happy to say, they provided me a window into one of Milwaukee's genuine architectural treasures.

Pabst's Chicago World's Fair Pavilion Survives in Milwaukee

Thanks to Erik Larson's 2003 bestseller, *The Devil in the White City*, yet another generation is fascinated by Chicago's 1893 World's Columbian Exposition. Despite its enduring—in itself somewhat surprising—popularity, little remains of this, by all accounts stunning, little temporary city.

One survivor is the fair's Columbian Museum, which now houses Chicago's Field Museum. Another is much closer to home, and it serves as the entrance and gift shop to the Pabst Mansion at 2000 West Wisconsin Avenue.

"The Pavilion was conceived as the Pabst Trade Pavilion at the World's Fair in Chicago in 1893, and Pabst and Schlitz were the two main Milwaukee brewers that participated in sending exhibits to the Cultural Building in Chicago," says the Pabst Mansion's director of development and senior historian John Eastberg.

Unlike the mansion, which was constructed in 1892 to the specifications of Ferry & Clas, the pavilion was designed by Milwaukee architect Otto Strack, who served as Pabst Brewing Company's architectural superintendent, according to Eastberg.

The buildings share architectural elements and matching terra cotta, and Eastberg said that his research has shown that Captain Frederick Pabst always intended to bring the pavilion back to Milwaukee. At the fair's close, it was dismantled and shipped up, where it was erected first on the lawn.

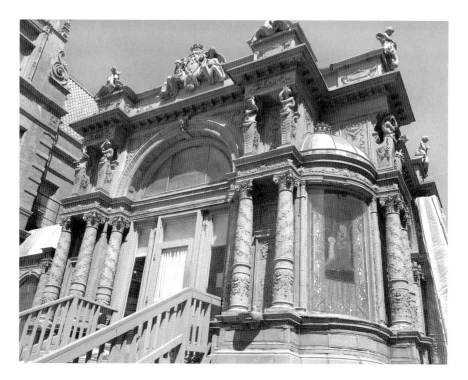

The Pabst Pavilion was designed and constructed for the 1893 Chicago World's Fair and is one of just a few exposition structures that survive today. Brought back to Milwaukee, it was annexed to Captain Pabst's mansion.

"September [2013] is my twentieth year here at the mansion, and I just figured this out last year," said Eastberg. "I found a very short article last year that stated in essence that the pavilion had been built as a stand-alone thing on the west lawn, and it turned out it was blocking the view from the windows, so they decided to take it down and move it to the east side of the mansion."

The sturdy construction appears to be proof of its intended permanence.

"They just would've made it out of plaster and glass just like everything at the World's Fair," said Eastberg of Pabst's desire to construct an enduring structure. "They wouldn't have done terra-cotta blocks and stained-glass windows and all that. What I think is really funny is that the building was actually on the second floor of the agricultural building, so knowing the size of the pavilion and its weight, it kind of freaks me out."

But most were anything but freaked out about the pavilion, which was built to boast of Pabst's wares—and the buildings in its Milwaukee

brewery complex—to the more than 27 million people who visited the fair during its six-month run from May 1 through October 30, 1893.

"The building was really remarkable. It got a lot of great press at the time, and after the World's Fair was over, Pabst had secured the gold medal for brewing. The one thing that I do have to laugh about is that Captain Pabst did win the gold medal for brewing, but there was never a blue ribbon," said Eastberg.

The square pavilion is heavily decorated with figures and ornament and capped with a now oxidized green copper dome. It was joined to the mansion's east elevation via a barrel vaulted passage that was topped with clear glass, flooding the pavilion with light.

After Pabst's death, the mansion was sold to the Milwaukee Archdiocese, and the pavilion, which the family had used as a conservatory, was transformed into a chapel. A cross was added, the clear barrel vault was covered, windows were replaced with stained glass and the decorative interior of the dome, which was wrapped with a frieze depicting the history of brewing and featured a stained-glass window, was heavily altered.

As beautiful as the pavilion is, it has faced a lot of struggles, including a deadly one against nature. Water has seeped in and compounded structural issues.

"There definitely is a disconnect between the rest of the mansion, which is in really fine condition, and the pavilion," said Eastberg. He continued:

> Basically the underlying problem is that there is a bad structural steel frame in it that's corroding and pushing those blocks of terra cotta out and cracking them and letting the water in. It's kind of moving, in essence. We've had structural engineers out and they're like, no, it's safe. There are basically two skins to this building. There's the inner one that you see in the pavilion, the steel frame that's supporting both the inner skin and the outer skin of the building, which is having more substantial issues. They're moving basically independent of one another, so there's more damage on the exterior than the interior.

The problems have been ongoing—Eastberg has seen photos dating to 1910 in which damage to the terra cotta can already be seen—and he says as they've gone unfixed, the cost to repair the pavilion has skyrocketed. Now fundraising has stepped up as the Pabst Mansion attempts to raise $5 million to restore and shore up the pavilion for future generations.

In spring 2013, Eastberg led a bus junket to the Field Museum to see an exhibition on the world's fair to help raise awareness of the condition of the pavilion:

> *This has been an issue for a very long time. When I first started here in '93, people thought for a couple hundred thousand dollars you could really get something fixed, but what's going to have to happen now, is that the entire structure has to be completely dismantled, that steel frame has to be taken out. The stainless steel frame has to be made, and replacement terra cotta has to be made. And every block has to be assessed for its viability going forward.*
>
> *We've done our historic structures reports, so we know exactly what's the matter with it and how to go about that. We've created the scope, so we know what elements we would be putting back, and we are going to take it back to putting the stained-glass dome back on. All the elements that were there will be back.*

The promise of restoration is exciting from historical, preservation and architectural standpoints, but the planned future use for the pavilion is exciting from a travel and tourism point of view, too.

"We are currently planning on turning it into the Pabst Palm Garden, which would be a mix of the way the Pabsts used it here at the mansion, but also hinting at the way it was at the World's Fair," says Eastberg. "It would be a sample/tasting space at the end of your tour where you could sample Pabst products."

That goal is part of a larger campaign to build a visitors' center across Wisconsin Avenue on property already purchased by the Pabst Mansion. That ambitious larger project—which would also house the gift shop and the mansion's offices—carries a $10 million price tag.

A half-million-dollar gift from the Pabst family has kicked off fundraising for the pavilion, and once the kitty has about $3 million, said Eastberg, the work can begin. In the meantime, he and his colleagues are making the rounds in Milwaukee and beyond to tell the story of the pavilion, which, he said, has a national hook:

> *We really do feel that being one of less than ten known remnants of the World's Fair has historic significance. The mansion itself is on the National Register of Historic Places, but we really feel that with the narrative for the pavilion, it warrants national landmark status.*

The National Trust selected the pavilion ten years ago as one of America's endangered treasures. That was completely independent—they actually came to us. I feel that people both in Milwaukee and outside Milwaukee actually get the importance of the pavilion.

Eastberg said he feels that after decades of delays, the time is right to really secure the future of what he calls one of the most significant historical pieces of architecture in Milwaukee:

I've been studying up on this for 20 years. It's funny—if you had told me 20 years ago that the pavilion would still be going, that would've been a lot to deal with, but I feel, finally, that we really understand the pavilion, its significance, where it needs to go. There have been certain technological developments that have helped. It's lasted over 120 years, which is pretty amazing. It's funny—when I was doing some research with the Archdiocese a number of years ago I found a letter in there from the '60s, saying that immediate attention needed to be placed on the pavilion and if [it was] *not, it was going to be too far gone. That was 50 years ago.*

Spelunking in Milwaukee's Oldest Brewery Building

Uneasy" might be a good word to describe the feeling I experienced as Adam Spoerri and I stood in a subterranean beer storage cave—out of service for well over a century—on Milwaukee's near South Side.

We had to traverse a low-ceilinged obstacle course of rusted and wet debris to get inside. Did I mention that course runs beneath four floors of caved-in building rubble? Yet walking into the remarkably preserved Cream City brick cave with its barrel vault and cobbled floor was a revelation. Like stumbling into a Milwaukee secret, albeit a poorly kept one.

"You can see the sinkholes over there," Spoerri said, pointing down the long, dark cave to a couple spots where the ceiling and the earth above it have fallen into the cave. "We're probably standing right underneath your car," he added, referencing the pebbled area where I'd parked an hour earlier.

On the way back out, as we were in the obstacle course attempting to avoid the rusty nails pointing upward, Spoerri said, "This is the part the city thinks will collapse at any minute." Despite his quiet, almost shy demeanor, Spoerri clearly has a sense of humor and a flair for the dramatic. I couldn't see his face in the dark, but I hoped he was smirking.

Spoerri is a partner in the nonprofit ReThink Factory, which works with groups like Sweet Water Organics and Urban Ecology Center as part of its mission to create more sustainable and resilient communities through a design/build education.

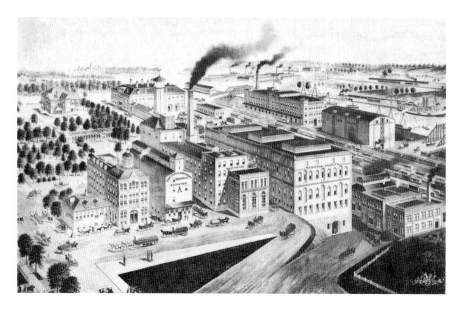

Though few can even see it tucked away into a neighborhood today, the Falk Brewery was once a hive of activity. *Courtesy of Historic Photo Collection, Milwaukee Public Library.*

ReThink is working to envision and ensure a future for a rarely seen bit of Milwaukee brewing history. Where South Twenty-ninth Street dead ends into the Menomonee Valley are the remains of Franz Falk's Bavaria Brewery, the fourth-largest brewer in the city in its day.

"The site is owned by Straightway Vineyard church, and my organization ReThink Factory is trying to redevelop the site and turn it into a social innovation hub and education center," said Spoerri. "We are currently looking for support and partners in this incredibly large undertaking."

"It is also currently on the city's hit list," he added, noting that the building is on the to-be-razed list. "But we are working toward fixing that. We were quite close to a historical designation, but the Common Council put it on hold until we deal with some structural issues."

The buildings are clearly of value in a city whose reputation and historical identity is fueled by beer.

Falk—his family later went on to build the Falk manufacturing empire nearby—started his brewery with Frederick Goes in 1855, a mere seven years after arriving from Germany. In 1870, Falk's brewery erected the earliest part of the Ice House, the building under which I'm standing

with Spoerri. A few years later, the only other extant brewery building—the stables—was constructed.

There were other buildings, but they were all lost amid numerous fires or were demolished over the years. One fire, on July 5, 1889, made national news. According to the city's historic designation report:

> *The fire started in the malt house in the early afternoon. On duty were the in-house fire crew but most of the employees were off work. Unable to access the water from the artesian well, employees called upon the Milwaukee Fire Department to help. By the time they arrived and set up at the river, the complex was engulfed in flames. The new boilers burst and the ammonia tanks used to make ice also exploded. The storehouse managed to survive although gutted as were the stables with their horses and wagons. Lost were the malt house, the brew house, the elevator, and the engine house with its expensive ice machine. Also lost was the office building. Only the vault was left standing.*
>
> *Although the storehouse survived, the 52,000 barrels of beer in storage there were ruined by heat. Some 50,000 bushels of damaged barley had to be sold off. Estimates for the damage ran from $700,000 to one million dollars. Insurance coverage was between $300,000 and $400,000. Other breweries offered their help to supply Falk, Jung & Borchert's customers. The Jackson Sentinel mentioned that the physical and financial loss was the biggest in Milwaukee history up to that time.*

That and a couple blazes a few years later helped doom Falk's brewery. Two in the space of three years caused financial distress that was impossible to overcome, and Falk gave in and sold out to Pabst in an acquisition ($1 plus $500,000 in Pabst stock, along with jobs for the Falk execs) that made the captain the city's biggest beer baron and his brewery the world's largest, for a brief moment.

A third building on the site, the office, was built by the Borchert Malting Company, which purchased the property in 1897, continuing Falk's on-site malting operation. Ernst Borchert was a partner in Falk. He took his parachute position with Pabst, leaving shortly after to get back into the malting game on familiar turf.

In 1919, Borchert sold to J.M. Riebs Malt and Grain Co., which did brewing, malting and distilling on the site until it, too, was taken down by fire in 1971. At the same time, the National Foundry Co. set up shop in

the stables, which it expanded over the decades until it was replaced by Schwerman Trucking in 1956.

The site had a few small operations—tire recycling, salvage yard—until the church bought it in 2009. Spoerri says the church hopes to renovate and occupy the stables, while ReThink is currently rehabbing the office into its own headquarters.

But the gem of the site is the icehouse complex, which had numerous additions in the nineteenth century. No one knows for sure who the architects of the building and its additions were, but some say Henry Koch (who drew plans for an "office building" for Falk in 1882), others suggest Henry Messmer and still others have reason to credit Chicago's Griesser & Maritzen.

Regardless, the stables and the icehouse are Cream City brick structures with Romanesque arches and, in the case of the stables, some unusual and fetching oculi in the east and west façades. The interior of the stables boasts some pretty intricate and colorful graffiti art.

The office, meanwhile, is a Colonial Revival structure with fine woodwork, etched glass panels and the original paymaster's counter. Work on that frame structure is underway. There are drawings of ideas for the brick buildings, but they can't move forward without a good chunk of change, which is never easy for a couple nonprofits to raise.

When Spoerri invited me over to see, he made an offer I could hardly refuse: "Two floors are only accessible by ladders, and there are actually large shafts called waterfalls you could rappel down if you wanted. There is also an underground beer tunnel only accessible through a collapsed section of the building. We will be going up and down ladders and through small holes cut into the floors."

And that's exactly what we did. We climbed ladders the likes of which I'd never ascend at home on my own, and we shimmied through a couple holes hammered through floors (or ceilings, depending on which side you're on). We peeked down those rectangular waterfalls that span the height of the building and four flights down into the collapsed rubble of the 1870 building.

There are still huge malting vats, which we viewed from above, below and alongside. There is an amazing grain elevator with long narrow cups that ride up and down a belt in a boxed-in shaft. Above our heads were huge wheels that helped run machinery. In one giant room, we could see the germination beds for malting.

Paint is peeling from most surfaces and stray lengths of old rope lie in heaps on the floors. Rusted metal tools and controls are here and there.

Because the windows are covered, we had to carry flashlights to make our way around.

But what was most striking was the silence. It was eerie to think of the activity that must have enlivened these rooms for decades, to think of the people who passed hours and days and years working in here for more than a century.

When we walked outside into the sunlight, Andy Tarnoff, who came along to take photographs said, "There are ghosts in my hair"—ghosts of Milwaukee's brewing past.

Downtown Tavern Is the City's Oldest Schoolhouse

I've been in Best Place before, with its intimate courtyard and stunning beer hall. I was even in there a few times when it was the visitors' center for the then-still-operating Pabst Brewery.

It's gorgeous, thanks to a well-preserved midcentury renovation that re-created a medieval German beer hall. Recently, I learned a bit more about the building's history.

Being an old schools geek, I was happy to learn that Best Place's building on the corner of Ninth Street and Juneau Avenue, which was previously a Pabst building, was even earlier the District 2 School, also called the Jefferson School.

Since so much of why we love a bar is because of its location, its atmosphere and its history, Best Place just might be my new favorite bar.

Built in 1858, the school was closed and replaced with a new building, designed by Edward Townsend Mix, on nearby Tenth Street and Highland Avenue in 1889. That same year, MPS sold the Jefferson School to Pabst, which removed the pediments and cornice and replaced them with castle-like crenellations and replaced the belfry with a taller crenelated tower so that the building would match the architectural style of the rest of the brewery's buildings.

Pabst reopened the renovated building as its new offices in 1890. Ironically, the Jefferson School has long since outlived its replacement, which was torn down decades ago to create the parking lot for the current MPS Facilities and Maintenance Building.

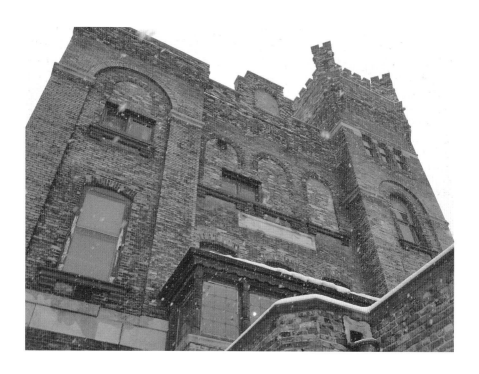

If you compare the Best Place building of today with old photographs, it's quite clearly the Jefferson School structure, despite some bricked-up windows, Pabst's changes and more than a century's work of gunk darkening the bricks. In the front corners, for example, you can still see the ornamental stonework, though you have to go into the courtyard to see the northeast corner.

Owner Jim Haertel agreed to give me a tour of the interior, though he warned me in advance there didn't appear to be any signs of its former incarnation as a school. As we walked through, I was pleased to see Haertel went back a bit on that assertion. Though it's often hard to tell what dates back to the school days, there is wainscoting throughout, along with window trim that looks a lot like similar details in old schools.

The pressed tin ceilings and the cast iron pillars don't necessarily shout "schoolhouse," but they look original. In the case of the ceilings, they were covered up later and have since been revealed.

Some rooms have hardwood floors that appear original, while at least one has what appears to be a laminate floor laid over the top. The staircases are wider than one would expect in a small office building and are most definitely original. Behind drywall, there are interior walls that are wainscoted and lined along their top length with transom windows that likely helped light the double-loaded corridor that appeared to have had, at most, a single window on one end.

Haertel says that up in the attic, there is a roof below the current roof, and comparing photos, we can see that the current roofline is higher than the original one, which explains it.

After Pabst bought the building, it opened the back (west) wall to connect the former school to an adjacent Pabst structure erected in 1880. But even inside, it's pretty obvious where one building ends and the next one begins. Down in the basement this distinction is even easier to see. After descending the steps, we realized that we were at the back of the original part of the school, which had an addition put on at some point.

Opposite, top: The oldest-surviving schoolhouse in Milwaukee is the former District 2/Jefferson School. It was sold to Pabst Brewing in 1889 and converted, somewhat, into offices.

Opposite, bottom: Though the first floor of the old Jefferson School was converted into a tasting room that is now a tavern, classrooms survive on the vacant upper floors.

On the wall next to the staircase, we could see some former basement windows and a change in the foundation construction. The addition is also obvious at the roofline. The original section has a peak running east–west, while the apparent addition's peak runs perpendicular.

While the main floor at Best Place is in terrific condition, the floors above require a lot of work. Haertel has plans, but he knows that it will take a lot of energy and money to make them happen. I hope they do happen, and I hope he's able to work the old school details into the new design to help preserve a real piece of Milwaukee's brewing and education history.

In the meantime, yes, you may now go to a school (albeit a closed one) and have a drink.

Pevnick Design's Tech Wonders Wow during Old School Tour

For a long time, I've been quietly trying to nudge my way in to see the former Clybourn Street School at 527 North Twenty-seventh Street, between Clybourn and Michigan.

On a warm September day, I finally got a tour, and my visit was a surprise, but not for the reasons I expected.

Built in 1878 as a District 16-2 annex (16-2 was the old Wisconsin Avenue School, whose building was replaced with the currently closed one in 1919), the school was renamed Clybourn Street School in 1912, when many MPS schools were renamed for their locations. It was also briefly called the Grand Avenue Annex, and for eight years starting in 1931, it was called Mary Hill, in honor of a district principal.

The school closed in 1939. But that seems almost hard to believe. Its tiny vestibule, short staircases and four classrooms with soaring thirteen-foot ceilings still shout "schoolhouse" thanks to nine-foot-tall windows, wainscoting all around, hardwood floors and tongue-and-groove planked ceilings.

There are also a number of unusual and striking radiators, including one that looks like it might have inspired the design of Harley-Davidson motorcycle engines.

Of course, I asked to see the attic. Unfortunately, the bulbs were out, so I didn't see anything beyond what I could make out from some haphazard flash photos I took. There's a ladder up to the old bell tower, but the tower fell into disrepair and was removed for safety reasons.

Like the Jefferson School, the former Clybourn Street/Mary Hill School retains classrooms that are mostly intact. Fortunately, the building's collection of unusual radiators remains, too.

The school's entry staircase was, at some point, replaced with the current porch. A large warehouse structure was added to the back, apparently in the 1940s, and that space was later enlarged, too.

The basement is exactly what you'd expect: rusticated stone foundation topped with Cream City brick walls with a small boiler room, though when it was built, the school was likely heated by stoves. By 1894, it had a boiler for steam and hot-air heating.

The building is owned now by Stephen Pevnick, who runs his Pevnick Design company out of the back. In the old building is a range of tenants, including musicians and dance studios.

The big surprise for me was to hear about Pevnick's work and to see it in action. Pevnick, an art professor at UW–Milwaukee, began looking into ways to intertwine rhythm and water in the 1970s and created technologies to make those explorations reality. He started his company, Pevnick Design Inc., and began creating graphical waterfalls and other water features and selling them around the United States to malls, office buildings, casinos, trade shows and the like. He pretty much had the sector sewn up until success propelled him to Europe, at which point larger companies with the financial wherewithal to do so were able to copy his work. But Pevnick and his Milwaukee-based company are still in demand. Just look at the map on the shop wall. Each pin denotes a job completed. The map—from the United States to Asia to Europe to the Middle East to Central America—looks like a pincushion.

Pevnick did many trade show exhibits for the likes of Kohler, Daimler Chrysler and Jeep. In 2006, he did an amazing display in Bangkok for a huge party thrown by the king of Thailand. He designed a water feature for the Atlanta Olympics. More recently, his work is what doused the band Fun on the Grammys telecast. In the summer of 2013, Pevnick created a fountain for Nestle that responded to questions posed by passersby.

Pevnick has thrown open the doors to his studio and to the former Clybourn Street/Mary Hill School as part of Historic Milwaukee Inc.'s Doors Open Milwaukee event. So you might get a chance to peek inside someday, too.

The Secret Indoor Track at Juneau/ MacDowell Montessori School

Whan my friend Gerry Belsha saw I had visited his alma mater—Milwaukee Juneau High School, now home to the MacDowell Montessori School program—to get a tour of the beautiful Moderne building erected in 1932 to the plans of Van Ryn and DeGelleke, he asked if I had seen the indoor track. I assumed he meant some painted lanes in the gym, but, no, he said, there was an indoor track in the basement accessed through a closet door. When I asked MacDowell principal Andrea Corona about it, she confirmed its existence, noting that it is unused today, as it has apparently been for decades.

One summer day, I stopped over to drop off some donated books for the classrooms and students at MacDowell and one of Corona's kind staffers agreed to show me the space. In the basement of the three-story, steel-frame building—which got a large addition to the south in 1976—is a double-wide doorway that leads into a sprawling storage area with a pretty low ceiling. Off to the right, through a wire mesh gate, is the track, which runs north–south just inside the east wall of the building, located on Sixty-fourth Street and Mount Vernon Avenue. The track is perhaps fifteen to eighteen feet wide and maybe eighty yards long—I didn't bring a tape measure on this impromptu visit—and the surface is some sort of soft black material that feels a bit like loamy dirt. Though long jump clearly took place in there, the headroom isn't generous. The ceiling's cross beams can't be more than eight feet off the ground, if that.

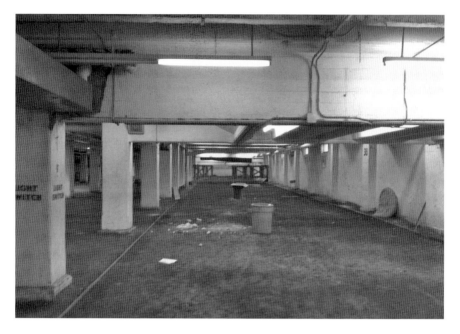

As far as anyone seems to know, the indoor basement track at the old Juneau High School is unique among Milwaukee public school buildings.

Opposite: In the earliest days of the track, records were painted onto the columns facing the athletes. Later, records were added in pencil, and later still, they ceased.

Along one side there are a couple four-tier bleachers that have reached an advanced state of deterioration. On the wall opposite are painted notes showing, for example, where to start a relay race. On some of the posts between the bleachers, record holders' names, times/distances and dates were painted. Later records were added in pencil below on some columns. Near the north end of the track are two swinging wooden gates. I have no idea what those were for.

I asked John Linn, MPS's manager of design and construction, if there are other subterranean tracks in district schools.

"That's the only one that I am aware of, and I found it by accident years ago when the high school was still open," he told me via e-mail. "It is amazing to think of kids running in there with the columns and walls so close!"

It appears that the track was not an original feature of the building.

"The indoor track area was not identified as a part of the original building construction as the space was simply identified as unassigned, and

I don't find any specific documents identifying the track construction," Linn said. "I did find a couple of drawings indicating the installation of surfacing for the long jump and high jump in 1968, which was done at the same time as new paving work on the exterior track south of the school, so my guess is that the work was either provided by Facilities [and Maintenance department] or the school without a set of actual [architectural] drawings."

The Juneau campus these days has a sprawling field across Mount Vernon Avenue and perhaps had space to the south before the addition was constructed, so it seems unusual to have an indoor track, too. Linn didn't know why it was built, so I tried to get more info from Gerry, who was at Juneau for the last three years of the 1970s:

> *I don't think it was open for actual use when I was there, but* [I'm] *not sure. When I was on the tennis team and we would run laps inside on*

bad weather days, we just ran laps around the school halls and not the track. I assume if the track was open for use, we would have used that. I know people would go in there—so access was not cut off—but I don't think it was authorized.

My stepdad was on the track team from '56 to '59, and they used it then. I think back then they had indoor-track season in addition to outdoor.

His stepdad told him the space was used for practice during the indoor season before weather was good enough to go outside. It was used primarily for sprints, though they did have a high jump pit. He also said it was used for archery competition but couldn't remember if the program was run by the school or a private archery club.

While this space is not exactly uncharted territory—some folks know about it, and some school staff, especially the engineers, go in there regularly—the existence of the space was news to a recently retired MacDowell teacher I talked to, and some current teachers didn't know about it, either.

Endangered Old Schoolhouses

When visiting a shuttered old schoolhouse, it's hard not to imagine the patter of little feet, the hum of a classroom full of kids or a lunchroom bustling with activity and alive with chatter. When visiting schools that are part of sets of twins or other "multiples," it's even harder to avoid comparisons between the "siblings." Take, for example, Thirty-seventh Street School, a couple blocks east of Washington Park, which was replaced with a new building nearly a decade ago—Mary McLeod Bethune Academy, around the corner on Thirty-fifth Street.

Built in 1903 and designed by architect George Birnbach, Thirty-seventh Street School is virtually identical to Auer Avenue and Siefert Schools, which were constructed the same year (though, curiously, those buildings are credited to architect George Ehlers). Those schools are all riffs on Brown Street, which was put up about five years earlier and designed by the firm of Mollerus and Lotter. These schools are also all still open and operating as schools. Inside, colorful examples of student art line the walls, coats hang on hooks in cloakrooms and voices and the rhythmic patter of dribbled balls echo around the third-floor gyms.

But none of these things are happening at Thirty-seventh Street School, which wears a coat of baby blue paint that is unique among Milwaukee public schools. Most of the lower windows are protected

The old Thirty-seventh Street School has some deterioration issues in the basement, but on the upper floors, it almost seems like classes are ready to begin soon.

with grates to prevent breakage and unlawful entry, which has been a problem.

What seem to be bigger problems when you go inside are the foundation and water damage. But those woes aren't new, it seems, and the building's issues were a large part of why Bethune Academy was built as a replacement. (According to the Bethune website, much of the staff who arrived from Thirty-seventh Street School remains employed even now. So the community really did simply move around the corner.)

Maintenance doesn't account for problems at the old school. After all, Brown is older and Auer and Siefert the same age, and they seem to be holding up pretty well. And I've met some of the folks who maintain these closed buildings, and they clearly take their work seriously—you can tell they feel ownership of these old places.

Regardless, emptiness hasn't been friendly to Thirty-seventh Street School, thanks to the constant attack of the elements, an empty and aging structure and troublemakers who make upkeep difficult.

The problems are worst in the basement, where a sprawling old kindergarten room with an open-concept bathroom (the only one I can remember seeing anywhere) has a great tile floor to match gorgeous tile work in all the school's restrooms. In the kindergarten room, with its *Laverne & Shirley*-style sidewalk-level windows, you can see water damage along the lower parts of some walls and on the floor.

Part of the basement is painted in what might be described as almost Packers colors: bright yellow and green, although a somewhat more teal-ish green than you see on the jerseys at Lambeau. Fortunately, that garish scheme didn't make its way upstairs, which is in better shape than the lower level.

The third-floor gym makes me want to do laps, though you'd have to do lots of laps in these so-called German gyms to get exercise. They're never very large (which explains, in part, why the district bought lots adjacent to schools in the 1920s to expand outdoor playgrounds).

As is the case with most closed schools, there are traces of occupancy that feel a little eerie, as if, on one Friday, everyone went home and simply forgot to return the following Monday. A sign in the corridor welcomes parents. A chalkboard message advises, "Sit tall, eyes on the book, answer on signal." An obsolete computer monitor serves as a doorstop. Inside the old main entrance is a big sign celebrating the Neighborhood Schools Initiative that led to the construction of Bethune and signaled the demise of Thirty-seventh Street. And posted above, in a glass-encased bulletin board, are architectural drawings of the replacement building. Even more prescient is the chalk-written note on another blackboard: "School is out: Any questions?"

To the northeast, just above Center Street, sits Fifth Street School, which was last known as Isaac Coggs School. Built in 1888 on a design by Herman P. Schnetzky—one of the architects of the Germania Building—Fifth Street was a larger version of Walnut Street School, built the same year and lost to fire in 1978. This Romanesque school is, in my opinion, an unheralded treasure in the city, with its prominent peaked section on the south end counterbalanced by a long wing stretching north up Fifth Street. There is some lovely brick detail and broad arched windows, which, like the painted bricks, are currently covered in whitewash. Though there is a buckled stretch of hardwood floor on the main level, Fifth Street is actually mostly in good shape. That's because it's been in almost continuous use since

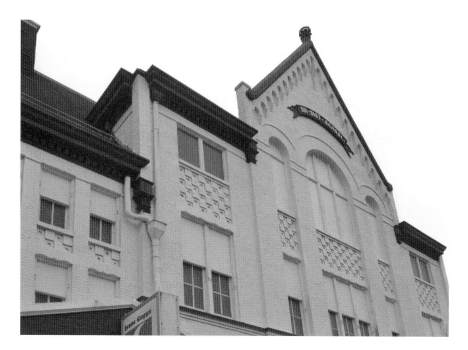

Old Fifth Street School has been vacant for a few years and appeared to be threatened, but lately, there's been talk of converting it into senior housing and a community center.

it was erected almost 125 years ago, its most recent use as a public health clinic. MPS transferred the building to the City of Milwaukee for that purpose after Coggs closed in 2007, and the latter subdivided classrooms into smaller, carpeted offices, exam rooms, etc. Much of the building was similarly altered. So while it's still plain to see that it was once a school, it would take a lot of work to rip out the changes and return it to a functioning schoolhouse.

Now the neighborhood is served by the MLK Health Clinic on nearby King Drive, and the Coggs clinic has moved into new digs up on Silver Spring Drive. Recently, the city returned Fifth Street to the MPS portfolio. We could speculate on the reasons why the city would opt to do that, but I'd be digressing.

As always, I especially enjoyed visiting the attics of the two buildings. In these old schools, you can see the carpentry work up close. At Thirty-seventh Street, there's even a beam that bears a carpenter's pencil marks from a century ago. It really gives you a sense of the craftsmanship that made these buildings stand so solidly for so long.

IN PRAISE OF CARPENTERS

Last winter, on a visit to a couple closed school buildings, I was in the attic at Thirty-seventh Street School and saw the pencil markings a carpenter left while framing out the roof of that school, built in 1903. While I'd often thought of the architects of these stately buildings hard at work at their drafting tables, I hadn't spent much time thinking about the hardworking folks who dug the foundations, set the limestone blocks in place, laid the bricks and framed the elaborate roofs. A couple simple lines executed with pencil and a straight edge of some kind immediately transported me back more than a century, and I could smell the scent of freshly cut wood and hear the sound of ripsaws and hammers at work. Nearby, I saw a bird's mouth cut into a joist to support a diagonal beam, and I realized the pencil lines I'd spied appeared to be a carpenter working out the proper angle for the cuts to create the nearby bird's mouth.

An hour later, I stood in the much more spacious walk-in attic at Fifth Street School, where the effect is more soaring than cramped (like it is at Thirty-seventh Street), and I paid extra attention to the carpentry. The framing in a school like that one (built in 1888), with a much steeper, complex roofline, looks almost like a spider web of wood.

Even with these two trips under my belt, I was still unprepared for what I saw when I switched on the light in a small, dark space I'd never been into before in the attic of the oldest part of Maryland Avenue School. Ducking through a three-quarter-sized door—the top corner of which is traversed by a joist, so watch your head—I could tell the space was cramped, and I could see there was a light switch. When I flipped it, I saw a sort of burnt sienna-hued ligneous fan. I was in the attic of the turret that is on the west façade of the original portion of the building, erected in 1887, and I was transfixed by the fan of joists. What struck me most was the heterogeneous spacing of the boards and the way they were trimmed to fit into the

Some of the most interesting sights in old buildings are hidden away in the attics, such as the interesting wooden "spokes" in the attic of the turret at the 1887 Maryland Avenue School.

tight grouping where they meet at the peak. This was clearly the work of knowledgeable and skilled carpenters. The web of joists wasn't generated by a computer; the boards were ripped by hand, not on a computer-driven saw. These days, something like this would likely be perfectly spaced, the boards perfectly trimmed. But here, a craftsman or a couple craftsmen worked together to create a turret roof by hand and eye.

Alas, my photos in this dark space—I was not there to photograph, so I didn't have anything more than my iPhone camera—don't show all the interesting details. For example, the roof boards nailed down to the joists are applied in an unusual pattern that is horizontal in one area, diagonal sloping north in another and diagonal sloping south in another.

An architect who was with me said he did a report on the Gallun Tannery buildings when he was in college and that he saw notes there on attic joists written in Polish and Italian. A couple other guys, who are much more adept at woodworking than I am, came in and were similarly impressed.

While we are often quick to recognize the artistry of the architects of Milwaukee's vintage landmarks, let's not forget about the folks who brought to life these drawings, who took an image on paper and rendered it in three dimensions for all of us to inhabit and admire.

Barring some unforeseen development, neither of these buildings—Thirty-seventh Street and Fifth Street—will likely ever be home to a school again. And for that reason, I call them threatened.

But as I write, a new plan has emerged for Fifth Street that includes nearly forty units of senior housing and community, green and parking space that would be shared with nearby Mount Moriah Baptist Church.

As Bethune was being built, there was talk of renovating Thirty-seventh Street into apartments—à la Mound Street and Jackie Robinson Middle School—but folks at MPS tell me almost no one even asks for tours of Thirty-seventh Street anymore, which means interest in it has waned.

That, plus its condition, make me fear for its future, too.

Malig's Work Is All around Us

We celebrate the work of famous architects. We know the names of Santiago Calatrava and Daniel Burnham, for example. But what of the folks who work in relative obscurity, designing the city around us from their desks at city hall or the municipal building?

Lately, I keep bumping into the name of Charles E. Malig, who, though he designed a couple public schools while in private practice, built many public buildings during his thirty-eight years as a staff architect with the city's Bureau of Bridges and Public Buildings.

The unique Kilbourn Avenue Bascule Bridge, built across the Milwaukee River in 1929? Malig.

The even more stunning glass-block bridge house at Cherry Street? Malig.

The fireboat station at the southern entrance to the Third Ward on Water Street and the Engine Company House No. 32 at 3920 West Vliet Street, with its elegantly tall, thin windows? Malig.

That little ward yard office building that is now part of Bel-Air Cantina on Humboldt? Malig.

The former Johnson Emergency Hospital and South View Hospitals on the South Side? Both Malig.

The Art Moderne Third District police station on Vliet Street? You guessed it: Malig.

According to a historic preservation report prepared by the city on the First Ward Yard Office, while private firms had typically designed civic structures in Milwaukee, the Great Depression changed all that,

Though his name is relatively unknown, civil servant and architect Charles Malig left an indelible mark on the city's landscape via his firehouses, bridge houses, public works facilities and police stations, like this Art Deco one on Vliet Street.

leading city fathers to bring a lot of that work in-house. The fact that Milwaukee's civic buildings continued to have a consistent look about them is due in large part to Malig and his talent and longevity.

According to the report, Malig, born in 1879, studied engineering and design before apprenticing at local architectural firms. Among them must surely have been the office of George Ehlers, for Malig is listed as "associate" on Ehlers's plans for the lovely Twenty-seventh Street School, now James Groppi High School, built in 1893. He landed his job with the city in 1911 and must have immediately begun working on the new wing of South View Hospital on Twenty-third Street and Mitchell Avenue, which went up the following year. Additions went on in 1916 and 1921, and after the first went up, the original nineteenth-century hospital—to which the 1912 building was an addition—was razed.

Malig and his wife, Kate, settled in on North Fifty-first Street in Washington Heights.

In addition to the structures mentioned above, Malig was also responsible for nearly every police and fire station, the Matthew Keenan Health Center on North Thirty-sixth Street, ward yard buildings, public restrooms and more. He initially began working in a bungalow style (see South View) but later became a big purveyor of the de rigeur Art

Deco movement, as is evidenced by the downtown bridges and the Vliet Street police station. He built five acclaimed bungalow-style firehouses in the city, too. One of them on Oklahoma Avenue currently houses the Milwaukee Fire Education Center and Museum.

As Malig aged, he developed an appreciation for modernism. According to another preservation report, this one from 2003:

> *City architect Charles Malig, with the Bureau of Bridges and Public Buildings, came up with a novel design for a low, residential scale building to house the fire engines and firemen. The brick veneered structures took on architectural detailing from the Colonial Revival and had the appearance of well-built, upscale houses. The Bungalow firehouse was the result. A number of these were built in the 1920's and several are locally designated under a thematic designation. The 1920's represented the high point of firehouse design.*

Malig retired from his city post in 1949 at the age of seventy and moved to a home on Seventy-second and Burleigh in the Enderis Park neighborhood.

"Malig can be credited, along with his staff," notes the preservation report on the First Ward Yard Office, "for helping create the 'golden age' of municipal buildings in Milwaukee."

A Look Inside a
Sebastian Brand Firehouse

Who doesn't love an old firehouse? Like many, I once thought it would be cool to live in an old one. You know, big open-concept place with high ceilings, history inscribed in every detail. Plus, you could slide down the brass pole to get to breakfast quickly.

The decommissioned Milwaukee Fire Department Fire House, Ladder Company No. 5, at 1945 North Bartlett Avenue, is one of those old places I've long suspected was ripe for such a conversion. For decades, it's been used by Kortsch Storage, which is headquartered in an awesome building at 2403 North Maryland Avenue. Thanks to our recent office move, my employer had some stuff at Kortsch, and one day, while on site to sort through our things, I got an impromptu tour of the firehouse. Hey, it pays to ask.

German-born architect and Milwaukee firefighter Sebastian Brand designed the two-story firehouse that was built in the high Victorian Italianate style in 1886. It's a Cream City brick structure sitting on a rusticated limestone foundation. There are eye-catching decorative brickwork just above the doors and near the eaves. The building doesn't appear to have changed all that much over the years thanks, in part, to the fact that no one ever converted it to a residence or much of anything else. On the north exterior wall, a ghost sign advertising Kortsch Storage can still be seen.

Engine Co. No. 5 moved up Bartlett to a lovely old house on Park Place in 1914, and after a string of tenants—including an MPS

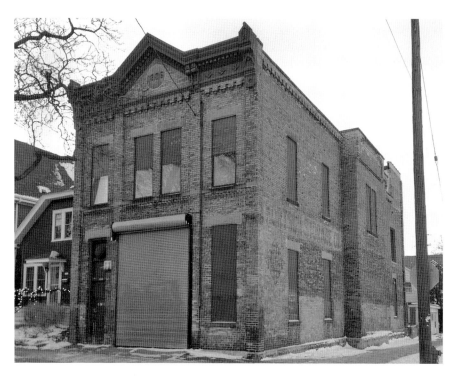

Before Malig was designing firehouses, that work fell to Sebastian Brand. Brand's Ladder Company No. 5 at 1945 North Bartlett Avenue has been used by Kortsch Storage for so long that the company's own advertisement on the north wall has become a ghost sign.

social center (presumably like one named for the Beulah Brinton in a decommissioned Bay View firehouse) and the Irving Athletic Club—Kortsch bought the building in 1924 for $10,000. Kortsch added a freight elevator to the northwest corner and a small penthouse tower to make the lift—which runs off an old Allis-Chalmers motor in the tower—possible.

There are wainscoting and weathered hardwood floors throughout the firehouse. At least one gas jet still remains, as does all the decorative molding around the windows on the interior. Some of the brick pavers that once stretched from the building to the street survive outside the entrance, as does woodwork in the staircases. My favorite detail is the swooping, curved molding atop the wainscoting in the staircase between the first and second floors.

There is a circular hole—and two rectangular ones—in the first-floor ceiling. I'd guess the round one was once pierced by the brass pole (which

is no longer there). The others may have served as access to the hayloft, as the station was built when horses powered fire trucks.

In 2003, the station house was designated a historic structure by the Milwaukee Historic Preservation Commission and the Milwaukee Common Council, and as is always the case, a report was prepared as part of the process. The report reads:

> *The Milwaukee Firehouse Ladder Co. No. 5 is significant as an important example of civic architecture from the 1880s. It was a symbol of the city's first attempts at standardizing station house design in an attempt to provide a state of the art facility that was economical as well as recognizable to the populace.*
>
> *It is also significant as the earliest surviving station house designed by Sebastian Brand, a Milwaukee firefighter who was elevated to the role of fire department architect and who put his distinctive stamp on station house design for over 20 years. Brand was the first municipal employee assigned to design buildings for the city and left a legacy of finely detailed High Victorian Italianate structures, of which only a small number survive.*

According to then fire chief James Foley, Brand was not paid extra for his designs, nor was he paid for the work he did to supervise the construction of the firehouses he designed. But perhaps the fact that a number of his stations not only survive but also still operate is a posthumous honor that might go some way toward rectifying that.

The Public Service Building's Art Deco Auditorium

Buildings come and buildings go. And the ones that stay with us for a long time rarely stay the same. Often we no longer notice additions and alterations undertaken decades ago, even when they're executed in a variety of styles and voices.

A number of people have raved about the gorgeous auditorium in the equally stunning Public Service Building at 231 West Michigan Street, but not a single one thought to mention that this space is an Art Deco gem inside a Beaux Arts/Classical Revival masterpiece. The PSB is part of a two-building WE Energies headquarters complex connected by a skywalk over Everett Street. It was heavily renovated in the 1990s, at which time, a fifth floor, added in 1956, was removed.

Of course, when Herman Esser designed the building, which opened in 1905 as downtown's interurban passenger train depot for the Milwaukee Electric Railway and Light Co., the auditorium was decorated in the same ornate style, with plaster garland on the balcony and pilasters soaring from floor to ceiling.

At the start of the 1940s, the PSB was, according to John Gurda's Path of a *Pioneer: A Centennial History of the Wisconsin Electric Power Company*, serving more passengers riding Greyhound buses than were taking trains. At the same time, the auditorium was given a makeover in the Art Deco, or Moderne, style, which was still in fashion.

During the war, the shiny new space was called into service as a center for USO dances, war production award ceremonies, draftee orientations

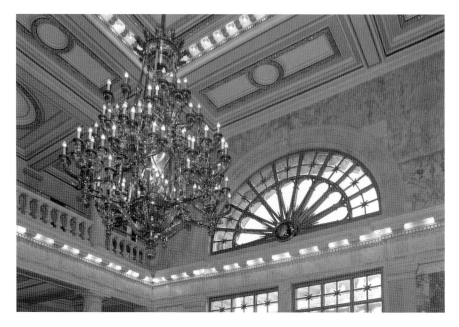

The Public Service Building, now a WE Energies office building, was erected as a train station, and older Milwaukeeans remember entering this ornate lobby on the way to or from a train platform.

Interestingly, the Classical Revival Public Service Building is also home to a fine Art Deco auditorium, which is now used for WE Energies meetings and events.

and other events. These days, it is used mostly for WE Energies events and meetings, but it is also used by outside groups like the Milwaukee Press Club for functions.

Guests these days are greeted by rich wood doors with sleek bronze stripes before entering from the back of the room, in a low space beneath the balcony that runs the width of the auditorium.

The upper parts of the walls are painted a creamy almond and are striped in turquoise and taupe. The lower sections, from the floor to about seven feet up, are paneled in a blond wood. There are decorative carved panels, and flanking the stage is elaborate turquoise and bronze metal work.

The ceiling, with its attractive circular vents, is bisected lengthwise by a five- or six-foot-wide plaster strip that is striped and decorated and draws the gaze straight up to the stage, above which the strip curves down to meet the curtains.

Turning back toward the entrance, a gaze up toward the balcony will reveal the silver and bronze Art Deco clock, tacked at all four corners by five-pointed stars. Even the women's lounge in the auditorium is ornate, according to my tour guide. (It was in use during my visit so I didn't get to see it.)

Not much else in the building matches the auditorium anymore, but there are plenty of fine details remaining. The lobby has splendid tile work, a gorgeous fan window above the entry and marble throughout.

A former vault is now a coat room on the first floor, and tile work, decorated with olive branches—looking like it's straight out of Pompeii—can be seen inside, too. A pair of elevators boast patterned brass doors, and a little farther along on the main floor are supple, curved brass railings that trace a marble staircase to the lower level.

The main staircase in the center of the building is marble and brass and switches back on itself, offering Escher-like views from below and above.

Upstairs, former cashier windows (PSB used to sell appliances) are preserved in the on-site credit union. Just outside the auditorium is an old ticket booth. Stained glass can be found upstairs, too.

What you won't find anymore are the bowling alleys, indoor golf course, barber shop and billiard room that once existed here. Nor will you find tracks or the wide-open platforms you'd expect in a building built as a station. All of that has been recast as office space for the roughly five hundred WE Energies employees who have the pleasure of entering a real Milwaukee architectural and historical gem on a daily basis.

Wisconsin Telephone Building Survives a Century of Change

Hard as it is to believe, there is one downtown Milwaukee building that is basically hardwired to almost every building and residence in town. That is the Wisconsin Telephone Co. (now AT&T) Building at 722 North Broadway Avenue.

Erected in stages beginning in 1917, the steel-frame building sits atop a huge subterranean vault that connects the building's numerous technology floors to substations that then connect to most every home and business in Milwaukee and, theoretically, beyond. Whether or not you still buy home phone service, that wire connection is likely still there.

Recently, I got a quick tour of the building, which was designed by Alexander Eschweiler. If the exterior brickwork didn't give that away, the multicolored stone in the fireplaces in the offices on the tops floors would have.

It's interesting to trace the development of the building in its first dozen or so years. It went up in '17 as an eight-story, flat-roofed building faced with brick except on the façade of the first two floors, which was granite. There was a cornice at the top and terra-cotta decorations. The building was constructed to be expanded, according to an unsigned, undated report that AT&T's Jim Greer gave me on the tour. It noted, "Columns were conveniently continued through the roof where they were capped, ready for the next building phase. The stairwells were large and space was provided for six elevators. There is no indication, however, that subsequent building phases were designed [at the beginning]."

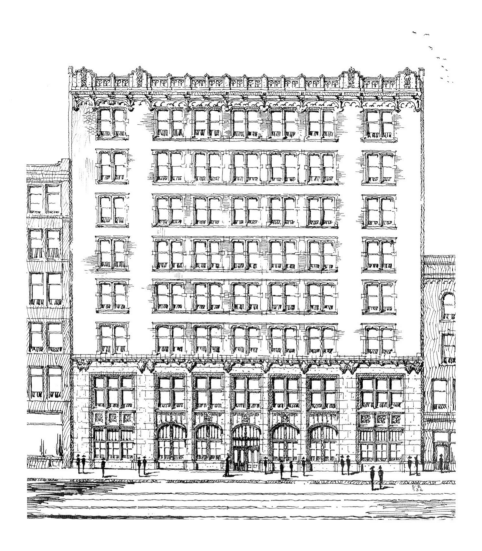

In 1924, Eschweiler designed five more floors that were added to the top, plus a three-story tower (that also included a seventeenth level for mechanicals). Finials were added at the two west corners of the thirteenth floor, four smaller ones marked the corners of the tower and a lantern sat near the peak of the roof.

It was during this time that the easternmost ends of this U-shaped building were bridged at the thirteenth floor. Today, this bridge, inspired by Venetian Gothic bridges, houses a conference room with views out over Milwaukee Street. The west-facing windows have been covered up.

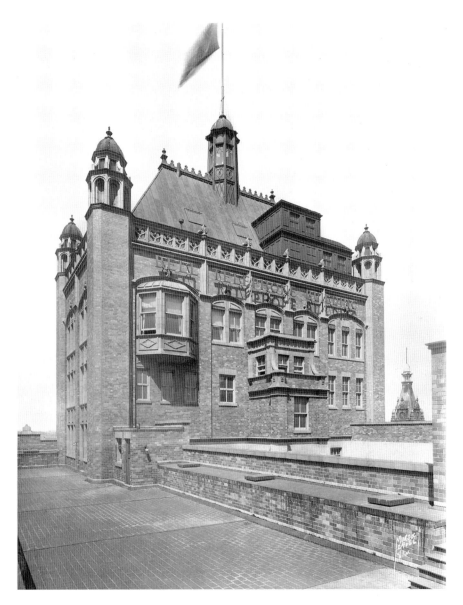

Above: At the pinnacle of Eschweiler's Wisconsin Telephone Company building is this three-story tower that looks like a complete building in itself. *Courtesy of AT&T Archives and History Center.*

Opposite: Renowned Milwaukee architect Alexander Eschweiler designed the Wisconsin Telephone Company building in the heart of downtown. Here we see an architectural rendering completed before the building's construction in 1917. *Courtesy of AT&T Archives and History Center.*

What's interesting is the next expansion in 1929. While the written history says floors seventeen through nineteen were added to the tower, it is apparent that the tower did not get additional floors. Rather, the three extra floors were added to the main part of the building below. Also, though the old lantern was replaced 213 feet up, the six finials were preserved and added on to the newly expanded Gothic Revival building.

The annex to the north was added in the early 1950s, and at that time, the original two-story street-level façade of 722 Broadway was removed and replaced with the one you see today. Some details survive inside. There's a sturdy iron staircase in the north wing and some marble work, along with the fireplaces. But sadly, most ceilings have been dropped, and most other detail work has been lost, as has what was once described as "the extravagantly decorated lobby."

Nowadays, the lobby is fairly small, not especially lavish, and perhaps its most interesting feature is the '80s-era telephone booth that survives.

The once skylighted first-floor courtyard now has an opaque roof.

But the interior changes are to be expected in a building like this. It is still the epicenter for telecommunications in Wisconsin and technology changes have led to these many alterations.

"[Most people] absolutely don't understand it what's behind it," says Greer. "Everyone just wants to pick up the cellphone, hit the button and have it work. There's a lot of technical stuff…we have so much technical stuff going in and out of this building."

Consequently, it's a high-security place, and you'll be as unsurprised as I was to learn that I was unable to gain access to the cable vault and other tech sites.

"This is the largest central office technical wire line telephone facility in the state of Wisconsin, and so there's a cable vault; there's equipment downstairs," says Greer, in an eighteenth-floor office that offers fine views not only of Downtown, but especially of Eschweiler's lovely finials and the elaborate terra-cotta work. "Over time that equipment has gotten smaller as technology gets better. But there's still a need for the wire line at work. We sell U-Verse television over it; high-speed Internet travels over it. We're still investing in that and in our wireless network. We spent $140 million in the first six months of the year in Wisconsin."

Maybe someday I'll get a peek into the vault, and if they let me, I'll share it with you.

Inside the U.S. Federal Courthouse

In 2012, when making a list of ten great Romanesque buildings in Milwaukee, I couldn't help but include the Federal Courthouse at 517 East Wisconsin Avenue, one of the city's most visible—if not the most visible—examples of Richardson Romanesque Revival architecture. What makes the building especially interesting is the explosion of decoration on the exterior and interior. It's an example of what U.S. Courts librarian Barbara Fritschel calls "Richardson on steroids."

What makes it a little bit more intriguing is that visitors must pass through security to enter and then are forbidden to take photographs. And that's a shame, because it means very few Milwaukeeans get to see the richness of color and detail and light that makes the interior as attractive as the exterior, which is clad in gray granite from Mount Waldo, Maine.

The building—erected in spurts between 1892 and 1899 as the federal government sporadically ponied up funds—was designed by the colorfully named Willoughby J. Edbrooke and is listed on the National Register of Historic Places.

Edbrooke was born in Evanston and got his start in Chicago, working with Franklin Pierce Burnham (no relation to Daniel, apparently). The two collaborated on the Columbian Exposition in Chicago and on some other high-profile works, notably the Golden Dome on the Notre Dame campus.

After splitting with Pierce, Edbrooke moved to Washington, D.C., where he worked as supervising architect for the Treasury Department, for which he designed many post offices, courthouses and other federal buildings. Among them was Milwaukee's courthouse, which Edbrooke, who died in 1896, never saw completed.

The addition on the back was constructed in two phases, mostly to accommodate post office needs as well as the arrival of the FBI in the building. The first five floors were completed in 1932, and three more were added in 1941.

Fritschel, who trains the docents leading the Doors Open tours, showed me around the building. (Before you pass through security, try to find the artists' names integrated into the decoration painted on the vaults above. Ask a security guard to give you a clue.) We peeked into some courtrooms, spent some time in the atrium and wandered a bit more. To my disappointment, a climb up the tower, which had seemed permissible at first, turned out to be off the table, after the General Services Administration, which manages the building, nixed it.

The building—for which Edbrooke drew inspiration from H.H. Richardson's Allegheny (Pennsylvania) County Courthouse and Jail in Pittsburgh and which bears many similarities to Edbrooke's Old Post Office in Washington—opened in 1899 as home to the U.S. Courts. There was only one federal judge assigned to the area at that time, and he was assisted by circuit court judges, whose purview then differed from circuit court judges today, said Fritschel. However, the largest tenant in the more than 300,000-square-foot building was the U.S. Post Office, which occupied the area that is now the atrium floor.

Walking through the elaborately tiled foyer and into the glare of the five-plus-story atrium, with its sprawling skylight, we came to stand in the former post office space. Rising to about the second floor is a steel frame that once was covered in glass. A walkway spanned that lower

Opposite, top: For years, the view up the atrium in the Federal Courthouse was obscured by opaque glass. Before that, there were catwalks and transparent panes that allowed supervisors to keep watch on the postal employees at work below.

Opposite, bottom: The original painted directory survives in the courthouse stairwell, even as many of the offices listed have vanished. Milwaukee no longer has an oleomargarine department, for example.

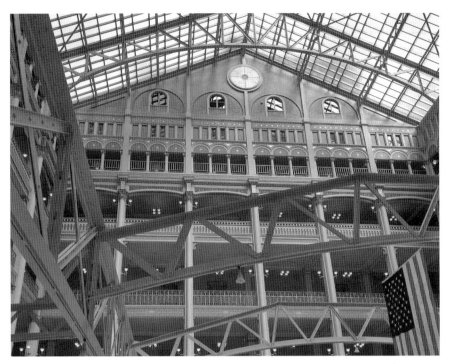

skylight, allowing postal inspectors to keep an eye on the post office employees below.

The post office remained in the building until a new one was constructed on St. Paul Avenue in the late 1960s. Afterward, the atrium floor was recast as an Internal Revenue Service office, and the space was divided up into offices. When a heavy object accidentally fell through the skylight—no one was injured—the glass was replaced with a less-than-attractive opaque covering.

The IRS later moved into the Henry S. Reuss Federal Plaza, 310 West Wisconsin Avenue, built in 1983, and the atrium was restored as part of a major, seven-year renovation launched in 1989. The steel frame was kept but left uncovered. So really, we're the first generation of folks to be able to stand on the floor and peer unobstructed up to the roof skylight.

While gazing upward, you can see how the railings on each floor are unique. And what a view it is, with more than two miles of ornate leafy decoration swirling around. Inside the building, exterior motifs are repeated. The dragon heads atop the dormers appear over doorways, faces from outside pop up atop capitals, windows facing the atrium have Romanesque arches. In the 1999 Centennial Courtroom on the Jackson Street side, a shield motif reappears directly behind its exterior counterpart.

What the inside can boast that the outside can't, however, is incredible oak woodwork throughout: doors, ceilings in the main stairwell and, above all, the ornate detailing in the stunning Ceremonial Courtroom— the oldest of the thirteen courtrooms in the building.

In addition to the millions of one-inch tiles that adorn almost every square foot of floor in the building, there is a wealth of marble, and a fair bit of trompe l'oeil marble, too.

One of my favorite features in the building is the directory board facing the elevator, just west of the main entrance. Here you'll find an interesting listing of the departments that once shared the building with the courts and the post office. The second floor was an especially interesting place, housing steamboat inspectors, the IRS, the "Wine and Spirit Department" and the "Oleomargarine Department." Other floors were home to the weather bureau, the U.S. Inspector of Locomotives, the Bureau of Animal Industry, the U.S. Lighthouse Inspector and the Referee in Bankruptcy. Note that while the assistant custodian had an office, it appears his boss wasn't so lucky.

Whether or not that'd be my favorite if I had visited the tower, I can't say, but I did give Fritschel my card, asking her to file it under "tower" and to let me know if an opportunity to climb ever arose.

In the meantime, I'll keep admiring its profile in the Milwaukee skyline.

Like a Moth to the
Wisconsin Gas Flame

These days, it seems like everyone's headed up to rendezvous with the weather flame atop Alexander Eschweiler's 1929–30 Wisconsin Gas Light Building at 626 East Wisconsin Avenue, but when I was offered a chance to get a tour, including climbing up to the flame, I wasn't about to say no.

Many of the floors in the building that Russell Zimmermann celebrated in his *Heritage Guidebook* as a "fine specimen of the rectilinear skyscraper style of architecture" are occupied by departments of the federal government, and visitors must pass through security and generally aren't free to wander at their leisure. Once in, however, you can see the stunning—though altered—lobby, with its striking bronze-and-marble detailing. Stepping into the lobby, which used to have staircases flanking the opening to the elevators (those staircases have survived behind the walls—there's an access panel to get in), you just might be reminded of the interiors of the Art Deco masterworks at New York's Rockefeller Center.

"This iconic representation of downtown Milwaukee has roots that spread farther and shine brighter than the flame that tops it," said Historic Milwaukee Inc.'s Amy Grau. She continued:

> *Milwaukee has memories here, with generations of families who have worked here, and a rich history continuing to be made here. People remember seeing the flame on the news as part of the weather forecast, know the flame rhyme and appreciate the Eschweiler architecture that*

About a decade after Eschweiler's Wisconsin Telephone building poked into the city's skyline, his iconic Wisconsin Gas Light building arrived. Ever since, Milwaukeeans have looked to its flame for impending weather changes.

makes the Gas Light Building a standout structure in the Milwaukee skyline. It's a wonderful representation of the city.

When the building does open for tours, visitors typically get a chance to see the old Wisconsin Gas Light Co. offices on the seventeenth floor. There's a big, old boardroom up there with great views out over the Milwaukee Art Museum to the east, as far as the eye can see to the south and down along Wisconsin Avenue and even out to Miller Park to the west.

You can also step out onto the small observation decks created by the building's setbacks at that level. One has a table and chairs as proof that folks don't take the views here for granted. One thing you cannot do is climb three more flights up to the flame, which, incidentally, is currently only lit three hours a night due to the expense. But building owner Paul Weise is working to replace the incandescent bulbs with an LED system that is less expensive to operate and maintain. Then, the flame will be illuminated all night long.

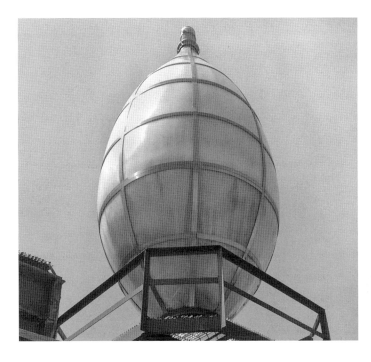

Most Milwaukeeans, especially those of a certain age, know the local code for the flame's colors: "When the flame is red, warm weather ahead. When the flame is gold, watch out for the cold. When the flame is blue, there's no change in view. When there's a flickering flame, expect snow or rain."

Though the first staircase up to the eighteenth floor is lovely and plenty wide, the next one up to the nineteenth floor is less so. Those floors house HVAC systems, elevator motors, an indoor water tank to help maintain water pressure and the like.

To get to the roof, there is but a metal ladder. And once you're up there, the small space is packed full of infrastructure. To make your way to the actual flame, you have to walk along a narrow metal walkway and up another short ladder through an opening. It's not for everyone, and it's surely not recommended for crowds.

You don't need to go to the roof to be wowed by this building, either. Here are some interesting facts about it, courtesy of tour guide Jim Drescher, who manages the property:

> *They started* [building] *this in 1929, and a year to the date, they were already in this building. It's unheard of. They built a floor a week out of steel, and then they followed up with all of the masonry work. They had over one thousand people on the work site in a day, and they had one thousand people waiting to work because of the Depression. They had six hundred masons (three hundred masons, two shifts a day).*

Unlike the Northwestern Mutual building, which has all wood pilings in the basement, we have all concrete footings. The waste pipe is [a] four-inch galvanized pipe. All the pipes were fabricated on site. We don't have cast iron. As they remodel, there are plastic parts, but the original system is still here. In '50s or early '60s, they updated all of the electrical through the whole building.

All of the stone and granite on the outside of the building comes from northern Minnesota. We're still trying to figure out where all of the brick and marble came from. It was hard, if you think about it, getting all of those pieces of granite here in 1929.

When they dug the foundation, there was a tavern on the corner of Wisconsin and Van Buren, and they had acquired it. But it was in foreclosure, and they hit a stumbling block and couldn't get the property. So what they did—it was going to take them months and months—was started the excavation. They completely excavated underneath the tavern, and they held it up with scaffolding, held this tavern in place. Even though it was closed and nobody was in there, they couldn't take it down, so they started building around it. When they finally did acquire it, they took it down and finished that corner.

On the lower level, the basement level, we are twenty-five feet out. We're underneath the sidewalk of Van Buren and Wisconsin. Our building expands twenty-five more feet out. Our sidewalks are heated and that's because (the basement goes) right out to the curb line of Wisconsin and Van Buren.

Preserving the National Soldiers' Home Historic District

Somebody told me that out near the stadium there's like an old Civil War town or something. Is that true?" A friend of mine who is very knowledgeable about Milwaukee—of which he is a native—and has lived here more or less his entire adult life asked me that when I mentioned I was taking a tour of the park-like grounds recently. It's amazing how close, and yet how unknown and misunderstood, the old Soldiers' Home on the Veterans Administration grounds, which is also home to Wood National Cemetery, still is to many Milwaukeeans.

Since the 1860s, the Soldiers' Home has offered services to area veterans, starting with, of course, Civil War veterans. Though it isn't the oldest building in the complex, the Gothic Revival–style Old Main, with its soaring tower and its hilltop setting, is the most recognizable. You can see it from the freeway. For years it took center stage over the outfield walls at County Stadium, and it's visible from Miller Park, too.

"It's really common, and I'm really even guilty of it," said Megan Daniels, author of *Milwaukee's Early Architecture* and a member of Milwaukee Preservation Alliance, who strolled the grounds of the Soldiers' Home recently, along with me; Dawn McCarthy, president of the alliance; and Elizabeth Hummitzsch, who is working to spread the word about preservation efforts at the site. "After the roof collapsed, that's when I first actually came out here to see it. You can see the tower from the freeway, and it's always like, 'What is that? What's going on over there? It looks really interesting.' But it's kind of lost out here."

Hummitzsch, who works for Mueller Communications, agreed: "That is certainly part of the struggle and I know that part of MPA's goal is to really let people know that this is here. You can come out here and walk around and take in these buildings."

The oldest section of the complex, where Old Main—designed by Milwaukee architect Edward Townsend Mix and constructed in 1869— is located, is an incredible small town–like collection of buildings that includes a hospital; a library; a barracks; Victorian homes that hosted chaplains, administrators and surgeons; a governor's residence; a social hall (with a bowling alley); a fire engine house; and other structures. Most were constructed with Cream City brick.

The MPA is currently focused on the stabilization of three structures: Old Main, which was used for veteran housing through the 1970s and, in more recent years, had a Medical College of Wisconsin crash lab, and the Ward Theater and the chapel, two buildings designed by German immigrant, Civil War veteran and landmark Milwaukee architect Henry C. Koch.

The 1889 nondenominational chapel has an entirely wooden facade. Its seven thousand square feet could hold six hundred worshippers, and it is among the earliest such facility on federal land and likely the first in the state. The white "shingle style" structure has a heavy, imposing tower and a façade that is decorated with an astonishing array of wood details. It's been closed since the 1990s, and it looks like it. Inside the chain link fence encircling the chapel, the exterior paint is peeling, and for our own safety, we were not even allowed inside, where, Hummitzsch said, there is water damage and leaking.

According to its website, the Kubala Washatko Architects is working with the National Soldiers' Home Foundation to restore the building and reopen it "for veteran use and funerals, as well as VA and visiting chaplain use, historic displays, weddings and other ceremonies, and multi-denominational, patriotic, and educational community events."

Opposite, top: Edward Townsend Mix's "Old Main" has been closed due to deterioration. However, work to stabilize it has taken place, and the height of the tower and its hilltop siting make it a visual landmark along Interstate 94 near Miller Park.

Opposite, bottom: Henry C. Koch's Soldiers' Home chapel is closed to the public and in need of repair, but it's still gorgeous. Because it's a shingle-style structure executed in wood, it is also a rarity among Koch's works.

Koch's brick Victorian Gothic–style Ward Memorial Hall (also known as the Ward Theater) was built in 1881 and over the decades hosted a wide variety of plays, concerts and other events, hosting the likes of Bob Hope, George Burns, Ethel Merman, Will Rogers, Nat "King" Cole and hometown boy Liberace.

"There will hopefully be some work going on there in the coming months," said Hummitzsch, at the close of 2012.

The whole site is listed on the National Register of Historic Places, but the Ward Theater, constructed in 1881, is listed individually on the register, too. It's easy to see why. Koch's Victorian Gothic–style building has an ornate wooden porch wrapped around a Cream City brick building with red brick decoration and lovely details. One such detail, a portrait of Ulysses S. Grant executed in stained glass, has been removed to safety while work takes place to stabilize the building in preparation for renovations.

Over the years, stars like Bob Hope, Liberace, George Burns, Nat King Cole, Sophie Tucker, Will Rogers and Ethel Merman have performed at the Ward, which across the decades staged vaudeville, variety and

minstrel shows, among other events. The building also served as a place of worship, had a restaurant and a post office and sold tickets for the rail line that ran right past it (and is now a paved path that is part of the Hank Aaron Trail).

Like the Ward, Old Main has been closed for a couple years. I was in Old Main briefly a few years back, but I regret not seeing the Ward at that time. Now, both are off limits except to hard-hatted workers. Old Main suffered a roof collapse in January 2011 and the Ward has damage, too.

"That was a lot of what spurred doing all this," said Daniels, "because it [would] stay open the rest of that winter, and all of 2012."

Work to make all three buildings watertight is complete, and MPA and Mueller Communications are working with the VA to spread the word about these historical and architectural treasures.

"The VA is responsible for upkeep these two buildings," said Hummitzsch. "So we've been working in partnership with them [and] with some groups of veterans and other stakeholders in the area to talk about how we might be able to restore these buildings, not just because they're pretty—although they are—but also to reuse them for their original purpose which was to serve veterans. That's the conversation that's going on with the VA."

"Their primary mission is veteran healthcare," added McCarthy. "That is their job, and so the idea of restoration…it's sort of like, 'It's not ours to consider.'"

McCarthy and MPA have worked hard to raise awareness and have gotten some help from the National Trust for Historic Preservation. In June 2011, the trust named the National Soldiers' Home Historic District one of America's eleven Most Endangered Historic Places. The organization's president Stephanie Meeks said at the time that the district "represents one of our nation's first efforts to provide veterans with the benefits they deserve…Today we ask that the place called home by veterans who have served in every American conflict since the Civil War receive similar respect."

In late 2012, the National Trust designated the soldiers' home a national treasure, driving even more attention to these threatened buildings.

"The National Trust is involved, we're involved [and] the State Historic Preservation Office [is involved] to commingle the VA's efforts to serve veterans and our interest to reuse existing and historic and gorgeous buildings to do so," said Daniels.

According to McCarthy, no fundraising has yet begun, but the recognition from the National Trust sets the stage for that to begin. Hummitzsch explained the effort's current status:

> *The phase that we're in right now is really trying to determine what these buildings could be used for. What needs are there that currently aren't being met for veterans and how might we be able to fulfill those needs in these building? That's a lot of the conversation that the MPA and the National Trust has been leading. So that when we get to the point of fundraising we can say, 'Here's what we're fundraising for.'*
>
> *A lot of it is initial conversations and creating relationships with the VA and creating a partnership. These are their buildings; they have to be at the table. And they've stepped up to repair these buildings to make sure there's no further damage happening as we continue the conversation. So we've been really happy with these recent developments that are really starting to protect the buildings.*

Restored Wright House Helps Return Luster to Neglected System-Built Homes

For years, the six American System-Built homes designed by Frank Lloyd Wright that fill the north side of West Burnham Street from Layton Boulevard to Twenty-eighth Street on the South Side were overlooked, if not downright neglected, by Wright aficionados.

The houses, designed by Wright from 1915 to 1917—the same time he was working on projects like the Bogk House on the East Side and the Imperial Hotel in Tokyo—were often ignored because they were "precut" homes, assembled on site. The result is that many of the built houses have been known or feared lost, and others, like the six in Milwaukee—that form a rare and major agglomeration of System-Builts—were radically altered or neglected.

Thanks to Frank Lloyd Wright Wisconsin (FLLW), that's no longer true. The group now owns three of the Burnham Street properties and earned a $150,000 Save America's Treasures grant in December 2007 to renovate the one at 2714 West Burnham Street.

"They have not been traditionally [respected]," admitted the Frank Lloyd Wright Wisconsin Heritage Tourism Program's Barbara Elsner, who has owned and lived in the Bogk House with her husband, Robert, since 1955. "But now it's different. Before it changed, the Museum of Modern Art [in New York] had a walkway connecting it to the shop, and

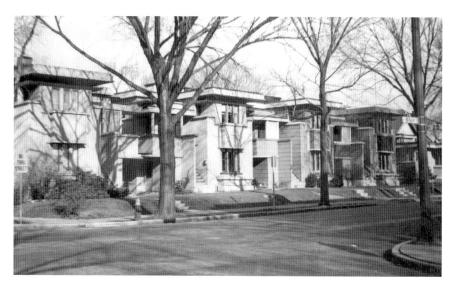

Frank Lloyd Wright's System-Built Houses were groundbreaking precut structures meant to offer affordable homes. Milwaukee's six—all in a row—are a rare agglomeration of System-Builts. *Courtesy of Historic Photo Collection, Milwaukee Public Library.*

the only thing for sale in there were four original System-Built drawings. That shows you how popular they've become."

But she agreed that it wasn't always that way. "Yes, only recently have they gotten interested," she said, noting, "Only thirteen have been identified up to now, and one other in Wisconsin is, I feel, suspicious. But you know they've been altered so much over the years that sometimes it's difficult to tell."

Elsner pointed out that there are more than nine hundred extant drawings Wright made for the American System-Built homes, which were meant to provide small, affordable, easy-to-construct housing and were far ahead of their time in philosophy, design and execution.

"You can imagine how complex [a project] this was," said Elsner. "There were thirty-six different designs with different kinds of roofs and variations that created hundreds of possible configurations."

A few years ago, a System-Built was lost in Gary, Indiana, serving as a reminder that these are endangered structures, in part because of their age and in part because of people's attitudes toward them.

So to step into the newly restored eight-hundred-square foot home at 2714 West Burnham Street is a revelation. It is as stunning a space as

Wright created anywhere. Walking over the threshold from the inviting front porch, one enters a towering atrium with windows at the top on two sides. To the left are two bedrooms and a full bath. To the right is the living room. Bathed in light, there are gorgeous woodwork and beautiful sight lines. There is a warming fireplace, and sitting in that front room, the street, just a few yards away, is invisible.

"I think the light in the space is amazing," gushed Elsner, quite rightly. "We had a UWM architecture student here who said, 'I can't believe this is only eight hundred square feet!'"

And it's true. While tiny by most modern standards, these eight hundred square feet feel double the size thanks to the open design and the wise placement of windows that was a Wright specialty.

Toward the back is an eat-in kitchen with dark wood cabinetry and a cozy built-in dining table and bench separated from the cooking area by a wood screen that allows light to pass through to create an airiness but offers distinction from the cooking space.

Fortunately, said Elsner—who noted that roughly fifteen coats of paint had to come off the walls—nearly all of the original woodwork survived in 2714 West Burnham. Farther along, the home at 2724–26 West Burnham Street—which Elsner and I didn't enter—is clad in aluminum siding.

"The only Wright house in the world with aluminum siding," noted Elsner as we walk past, toward the westernmost home.

Walking up a staircase that is literally beginning to crumble underfoot, we enter the upstairs apartment of the duplex at 2734 West Burnham Street, formerly home to a drug dealer it seemed. Inside, it's a disaster. There is a dropped ceiling, some windows are spray painted black and there is a distinctively unpleasant odor about the place.

"It's totally stripped," said Elsner glumly. "There is nothing of Wright left in here."

But that's not entirely true, and after living nearly six decades in a Wright house, Elsner has an eye for the details. And she pointed them out to me: a trademark Wright wood trim along the stairs in the back hallway, the way one entire wall in the kitchen is opened up with windows, the built-in flower boxes outside the windows.

This one, as bad as it looks, won't be impossible to fix. First off, there are those hundreds of drawings, which allow architects to see what Wright intended and how each room and the exterior likely looked. Then, there are the lessons learned from the work at 2714 and at the duplex next door that was restored by the family who currently lives there.

"A lot of the mysteries have been resolved, so this should be easier to restore," said Elsner.

Also, FLLW has earned a second Save America's Treasures matching grant—this one for $400,000—that will help cover the cost of restoring 2734 West Burnham. But the group needs to raise the matching funds before work can commence.

"We have our work cut out for us," said FLLW board member Mike Lilek in an issue of the Wright in Wisconsin newsletter. "This time we move forward with the sure and certain success of our recent restoration…The enthusiasm and response has been tremendous, and the feelings people have when they visit the home for the first time speaks volumes."

The goal of FLLW is to eventually acquire and restore all of the properties. They hope to keep a couple open as house museums to help document Wright's American System-Built Homes idea. Another idea could be to rent them out as guesthouses, like the popular Seth Peterson Cottage near Wisconsin Dells. The rest would be rented out to provide quality neighborhood housing.

The project got a public relations boost when it completed work on 2714 in 2009, just in time to host a visit from members of the National Trust Council, including Richard Moe, president of the National Trust for Historic Preservation.

"The Council was especially impressed with our visit to the Frank Lloyd Wright System-Built houses on Burnham Street," wrote Moe afterward. "Many volunteers have done a wonderful job preserving the legacy of Frank Lloyd Wright and his many designs."

Elsner believes the renewed interest in the Burnham houses has helped add Milwaukee to the itineraries of Wrightian tourists, too:

"A lot of people go to Chicago to see what's there, come up to Racine and then go on to Madison," she said. "There wasn't much here to see in Milwaukee. Now they come here to see my house and these [others], and now that we have the Calatrava, they stay overnight. That brings in tourism dollars. And when tourists come to see these they stay for a long time. They are very interested."

Behind the Scenes: Turner Hall

If you only visit Turner Hall, 1034 North Fourth Street, for concerts, it's easy in the dark of night and the dimly lit concert experience to miss the beauty of the building itself. Built in 1882 and opened in 1883, the impressive Romanesque Revival Cream City brick clubhouse was designed by Henry C. Koch—who designed Milwaukee's City Hall—for the Milwaukee Turners.

The building is a unique one with a two-story gym in the basement and another two-story ballroom perched above. Between them sits a sprawling restaurant and bar that has become famous over the years as a Friday night fish fry hot spot.

Outside, Koch balanced his façade with peaked wings flanking a central portion with three tall, slim windows—the kind that he used to adorn his Eighth Street School built in 1884—and capped it with a pointed tower. A small porch marks the entrance. Gorgeous red string courses add depth and color.

Inside there are murals, iron stairs dotted with circular glass details and woodwork galore.

According to its website, Turner Hall is the only Milwaukee building that is honored as a National Landmark, a local Historical Landmark and as a listing on the National Registry of Historic Places.

The building was the third home to the Milwaukee German Turnverein, a social, athletic and cultural organization founded in 1853 by German political exiles dubbed "Forty-Eighters." The group's

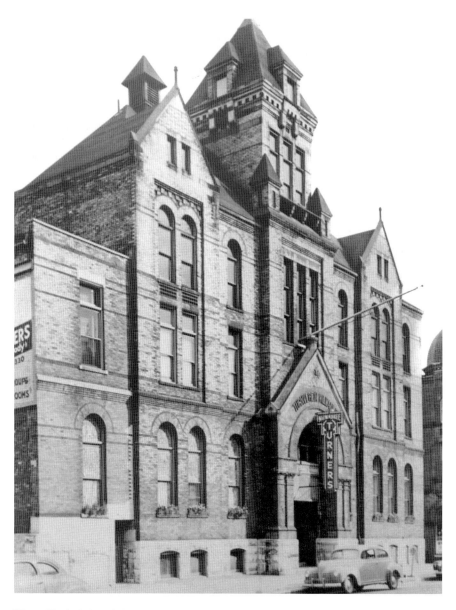

Henry Koch designed the symmetrical Turner Hall, built in 1882–83, when he was designing many Milwaukee public school buildings. So if you think Turner Hall looks a little like a school, with its copious windows and broad arched portal, you shouldn't be surprised. *Courtesy of Milwaukee Turners.*

Opposite: Formed in 1855, the Milwaukee Turnverein, or Turners, supported women's suffrage, social reform and honest and open government. These badges, worn by Turner members, are preserved in the Turner Hall office.

previous home sat just south on Fourth Street where there is now a parking lot.

These days, the Turners are best known for their focus on athletics and gymnastics, but the group was, in the past, known for its political power, too. Mayors Emil Seidel, Daniel Hoan and Frank Zeidler were among its members.

It's not surprising that Turner Hall's now wavy floors—a lot of settling occurs in a building built on a tamarack swamp—ooze history.

"When I come in the ballroom with tours, I ask the kids to imagine people with the 'eight-hour workday signs,'" said executive director Katharina Hren. "To have this room full of people rallying for that, the fact that they went to Bay View the next day, when the massacre took place—that it started here is kind of mind-boggling."

While exploring every nook and cranny of the old building with me and Andrew Nelson of the Pabst Theater Organization, Hren—a German teacher who was also director of the Goethe House for more than a decade—adds that among others, Eugene Debs spoke at Turner Hall.

The ballroom was also used for concerts and other amusements, and it is said that Charles K. Harris's multimillion-selling 1891 waltz "After

the Ball"—written while he was living in Milwaukee—was inspired by a visit to Turner Hall Ballroom. "After the Ball" was the bestselling tune in Tin Pan Alley history, which has led some to call it the first American pop song.

"You can't get this same sense of history in a more modern building," said Hren.

There were two fires in the ballroom, one in 1933 and another in 1941. That damage led to the closing of the space for many years. Now that it's been reopened, the damage is part of the history—and feels like part of the mystique—of the ballroom.

Of course, with history, come stories of hauntings, right?

"Kids touring with school groups often ask if there are ghosts here, which is not a comforting thought," said Hren.

"I've heard that the walls are filled with the ashes of dead Turners who requested that their ashes be poured in the walls," added Nelson. "There are certain stories that you hear. Maybe a ghost told me that."

"I don't know about that. It's possible," countered Hren. "What I do know is that I have three urns filled with ashes in my office that were found in the walls here."

We take a look at the ashes, which are just in plain boxes, with tags describing the contents, not especially creepy—at least not outwardly.

And there's not much creepy about Turner at all, really. If anything, inside there are elements that conjure a funhouse. There's that almost comically wavy ballroom floor, which in the cold light of day looks a bit like a rollicking sea. But don't worry if you feel it bouncing during a gig. The floor is built with spring action to absorb the weight and the movement. Another unusual feature is the raked stage, which slopes from the back toward the audience.

"Usually artists are a little surprised," said Nelson.

Up in the balcony, there is similar unevenness. Along the north wall is a doorway that over the years has slanted more and more. The solution? Keep planing down the top of the door to match the by now comical slant.

You might not have noticed the uneven flooring or the decorative woodwork along the balcony rail during a dark concert. In the same penumbra, you've likely missed the graffiti etched into the rail, too. The earliest dated one I found said "1919." But nearby, the name "Stoney McGlynn" is carved. Could McGlynn himself have defaced Turner Hall during his years with the American Association Brewers, 1909–12?

There's a lot of graffiti etched into the balcony of the ballroom at Turner Hall, including this one of two (presumably) carved by Stoney McGlynn (the other includes his last name), who was a star pitcher with the American Association Milwaukee Brewers from 1909 to 1912.

As always my favorite visits are to the attic and the roof. You can take a flight of stairs up to walk onto the ceiling above the ballroom and see the domed side of the recesses in the ballroom ceiling. You can also step out onto the roof and get a close-up view of the ornate tower and, behind you, the city skyline.

One more flight brings you into the tower itself, where there's more than a little dust and remnants of the pigeons that used to roost there. Intriguingly, there's also a discarded bit of metal roof decoration that begs for preservation. In the tower there's more graffiti, but that's more recent. Some are dated back to the 1960s, and one, written with a finger on a dusty window, can be easily traced to a current employee.

Down in the basement we saw the surprisingly large gym with its original balcony. We also saw where there was once a window that allowed parents up in the restaurant to watch their children in the gym below.

Although an old sauna is gone, a row of vintage lockers remains, as does a hatch that leads to a crawl space beneath the gym. Yes, I was tempted to go. No, I did not actually go down.

There's a modern climbing wall—much to the delight of many touring bands—in the gym. There are also two old cast iron dumbbells weighing in at seventy-five pounds each. The Turners, I guess, were serious he-men.

It's plain to see that Turner Hall has long been a place to relax and have a good time. That's a tradition, said Nelson, that continues today.

"This is where [Milwaukee's Germans] felt comfortable to come and be themselves," he said. "This was a gathering place where they could speak German. I like to think that since October 2007 (when the Pabst Theater Organization began staging concerts here), this has become a gathering place for like-minded people who could come and let their hair down, too."

Behind the Scenes: The Riverside Theater

In some ways the Riverside, 116 East Wisconsin Avenue, has always been the theater that almost never was. Erected in 1928 as part of the new Empire office building, which replaced a previous Empire building on the site, the Riverside Theater (which was designed by Kirchoff and Rose) opened just before America plunged into the Great Depression. Somehow, the theater—the bread and butter of which was vaudeville—survived, though vaudeville also took its final bow in the first half of the 1930s.

Long since recast as a film house, the Riverside fell on tough times, and by the dawn of the 1980s, there was a move to close the theater once and for all.

"It was literally one crazy man that was saying, 'No, we have to save it,'" said Andrew Nelson, spokesman for the Pabst Theater Organization, which now runs the venue. That crazy man, said Nelson, was Joseph Zilber, whose Towne Realty bought the theater in 1962 and still owns it today. Nelson continued, "Even internally, his staff was arguing against Joseph Zilber, saying, 'You can't make money here; there's nothing to do—it's way too big.' They wanted this made into additional offices. There was talk also of making it a beer garden, which is interesting…It was either fix it or gut it and do something else with it. They were going to remodel it and do offices or whatever." Other ideas floated at the time were for a retail center or a parking structure.

Zilber won, and fix it he did. An intensive renovation was undertaken in 1984, and for the next decade, the Riverside hosted performances by

There are numerous ghost signs in Milwaukee, but this confusing agglomeration of faded advertisements can best be spied from the roof of the Riverside Theater.

the likes of Aerosmith, Bruce Springsteen, the Beach Boys, Johnny Cash and Ray Charles.

"They had all the big names in the late 1980s and early '90s," said Nelson, including, he added, "my favorites, DJ Jazzy Jeff and the Fresh Prince in 1990 and Marky Mark and the Funky Bunch in '92."

Concerts continued under another operator for another decade, but the theater seemed to dip into limbo again before Michael Cudahy's Pabst team stepped in in 2006. Since then, the 2,460-seat entertainment palace has been livelier than perhaps ever, hosting the likes of Neil Young, Paul Simon, Jerry Seinfeld and Bill Cosby.

"It's had a tumultuous life span," says Nelson. "It struggled right from day one. It was kind of off and on."

But there were long runs of incredible activity. In the vaudeville and post-vaudeville era, Abbott and Costello, Red Skelton, Judy Garland and the Three Stooges appeared on its stage. By the '50s, folks could see Chuck Berry and Frankie Avalon at the Riverside.

"When vaudeville ended…it became mostly a film house until the '70s," said Nelson, who has taken an interest in the history of the venues his group runs and has been delving into archives to learn

more. "When I asked my parents if they had any memories of the theater their memories were of film. They saw *Ben-Hur* here and stuff like that."

On a recent tour, Nelson and Jason Millies, who works in the organization's facilities department, showed me the nooks and crannies of the place. And there are a lot of nooks and crannies. There are doors everywhere. Some lead to closets, others to backstage rooms and others into passages that lead to storage rooms. There were a couple that Millies hadn't noticed before.

Through a door in the eighth-floor backstage catering room, we found the mechanicals: the air intakes and giant wheels that turn giant fans that heat and cool the entire venue. These heating and cooling spaces—some now disused—are often big enough that you can climb right into them. Nearby, there is a random stack of cushioned chairs.

Through another door and down a wobbly ladder made of metal not unlike rebar, we came to the catwalks that encircle the dome above the ceiling of the theater, hundreds of feet up. Once in a while we could peer down through a hole at the seats below.

There are also strange ladders—hanging nearly horizontal by ropes—that no one really knows how to get to. Up here we could see the cranks and pulleys that allow the chandeliers to be raised and lowered.

On the river side of the Riverside are six floors of dressing rooms. That sounds impressive, but there's only really one per floor. Each, however, gets its own bathroom. Some, like one outfitted like Jeannie's bottle in *I Dream of Jeannie*, have vintage arcade games that get Nelson excited. On the small roof above, there are great views of the river and of some ghost signs on the neighboring Nelson Brothers building. One of them is low enough that it's obscured by the Riverside, suggesting it dates back to before the theater's 1928 construction.

In the basement, we were below not only street level but also water level, and down here, the first three feet of wall is fortress-thick. It also smelled strongly of tobacco thanks to Uhle's Tobacco Company upstairs. There's an ancient cooler down here that Millies said is likely to be torn down soon. Also down here, Millies has a makeshift workshop with a power saw to repair broken theater seats.

Upstairs is the old film projection booth, which has been converted to a lighting booth for concerts. But much of the old film-era equipment survives, including a rack of gear and a row of film reel storage boxes, one with an empty reel still inside.

On the stage is a metal spiral staircase that ascends up into darkness. Climbing up to the top made my thighs sore. The descent tested my fear of heights.

We talked a lot about the ghosts, but we didn't encounter any—that we know of.

"There are like three legitimate ghost investigators, and they all come through here on a regular basis," says Nelson, who mentions that Jay Reatard's final gig before his death in January 2010 was a New Year's Eve performance at the Riverside opening for Spoon.

While the Riverside has always played second fiddle—or opening act—to more glamorous and more popular venues in Milwaukee, unlike Reatard, the theater has kept going.

According to Larry Widen and Judi Anderson's *Silver Screens: A Pictorial History of Milwaukee's Movie Theaters*, the Pabst Theater Organization's work at the theater is good sign for the future.

"Efforts like Cudahy's are at the heart of the theater preservation movement," they wrote.

"This place is amazing because it's one of three remaining and two operating movie palaces in the city with the Oriental and the Grand," said Nelson, standing on the stage and gazing up to the chandelier, three stories up. "Larry Widen always speaks to how incredible [it is], considering the size of Milwaukee, that we have three movie palaces. It's extremely rare."

Behind the Scenes:
The Pabst Theater

Even in the most familiar places, there are hidden secrets revealed by different angles or unusual views that offer a new look at an old friend.

Consider the Pabst Theater: Certainly you know what it looks like from the street, and more than likely, you've seen it from a plush seat, too. Have you noticed that just outside the box office doors, between the theater and the adjacent Milwaukee Center, you can catch a towering view of city hall in the slightest sliver of light?

Get someone who works there and has some keys to show you around, and you'll find even more rarely seen spaces.

The Pabst Theater was built in 1895 by Captain Frederick Pabst after the Nunnemacher Opera House—designed by Henry Koch—which had occupied the site for twenty-five years, burned, leaving only an eastern portion that became a café until it was demolished in the 1930s to widen Water Street.

The Pabst, designed by Otto Strack, went up in just eleven months and cost $300,000 to build. The theater was renovated in the 1920s, at which point the building's foundation was replaced. The theater hosted performances by the likes of Richard Strauss, Sarah Bernhardt, Enrico Caruso, Noel Coward, John Philip Sousa, Arturo Toscanini, Katharine Hepburn and Sir Laurence Olivier, among many others.

By the late '50s, the theater was in need of help, and the City of Milwaukee purchased it in 1960. A decade later, there was talk of

Located across from city hall, the Pabst Theater has long held a prominent place in Milwaukee. Hard as it is for today's Milwaukeeans to imagine, the theater nearly faced demolition. *Courtesy of Historic Photo Collection, Milwaukee Public Library.*

demolishing the building, but Mayor Henry Maier stepped in and led a movement to restore it. It reopened in September 1976.

In 1989, the building's north lobby was added to connect it to the new Milwaukee Center, and two years later, the Pabst was designated a National Historic Landmark.

After Michael Cudahy purchased the building from the city, it again underwent restoration, and Cudahy's Irish Pub was added to the lobby on the site of the former Pabst Theater Café.

The Pabst stage has seen performances by Isaac Stern, Ravi Shankar, Wynton Marsalis, Jessye Norman, Leontyne Price and, in more recent years, many of the best bands in contemporary rock-and-roll.

I went spelunking in the theater one day with the Pabst Theater Organization's Andrew Nelson, and we climbed ladders, checked out the views from the roof and saw the awesome backstage set up to make the downtime most bands experience more pleasurable.

"I'm spoiled," Nelson said. "I get a daily backstage pass to the fourth-oldest active theater in the United States. My first Pabst Theater show, as a fan, was in January 2005. It was Bright Eyes with Coco Rosie, and

Tilly & The Wall. I remember thinking, how have I never been here? I felt like a young Indiana Jones discovering this ancient hidden palace. I was overwhelmed with civic pride that day. I was hooked. Less than three years later I was working here."

To get backstage, you can take the steps, or you can ride the elevator-like front portion of the stage that when completely lowered, doubles as the orchestra pit. When it's at the middle level, seats are bolted in, and it provides the first few rows of audience seating. Fully elevated, it adds about six feet of depth to the stage. When it's at the bottom, you can see the storage space beneath the floor of the theater, where the Pabst's organ—no longer used—is stored.

The carpeted backstage is like an amazing adult game room. There are video games, a turntable with a selection of vinyl, a cooler full of drinks, changing rooms, showers, comfy chairs and more. And that's just what you can see on a day when the theater is idle, said Nelson.

"What I didn't see from my seat in 2005 was what really goes on backstage," he said. "We have a master chef, sous chef, pastry chef making some of the best food I've ever tasted. We have a barista slinging drinks for the artists…It's a relaxing and vibrant environment back there. Typically, touring artists are not offered that kind of hospitality and never get off their tour bus. In Milwaukee, it's different. They not only get off their bus—they know they're in Milwaukee."

Climb up the metal spiral staircase in the wings, and it leads up to a series of tiny dressing rooms that are only used for big theatrical productions that require large casts.

About two flights up, there's a panel in the ceiling that opens. Engineer Samir Wahab—who has been at the Pabst since 1975 when it was being remodeled and is its living memory—grabbed a ladder, hulked it up the narrow, constantly curving staircase and set it up beneath the panel.

He climbed up, opened the panel and disappeared into the ceiling. We followed and found ourselves in the super cramped space housing the organ pipes. The pipes occupy what had been the "royal boxes" that were closed off during the 1920s renovation. There are giant wooden pipes that are square and of varying heights, and there are countless metal pipes that range from nearly cigarette sized to the size of the sewer pipe in your house.

If you peer closely enough at the black felt covering the large opening that afforded great private views of the stage, you can catch a glimpse of the main house seating.

Farther up the spiral staircase you can see decades' worth of graffiti scratched into the Cream City brick. My favorite is the 1980 Lenny and the Squigtones scrawl. The *Laverne & Shirley* spin-off band featured Michael McKean, aka Lenny, and a Christopher Guest on guitar, billed as Nigel Tufnel (making it something of a proto–Spinal Tap).

Though while up on the roof you're not high up enough to be able to get a great panorama, you feel like you can almost leap across and scale the city hall tower, making it one of the best views in the city.

We spent more than an hour checking out the catwalks above the stage, the ropes used to raise and lower backdrops, the basement, the physical plant, the old box office, the administration offices, the lighting box and almost everything you can think of. But there was still more, and one could spend days, weeks or more checking it all out.

"There are so many nooks and crannies in this place that you can only crawl through," said Nelson, who has seen more than most have. "My hands were black and my pants and hair were covered in dust when I was through. All the original brick from 1895 is along the back and has random names carved into it. All the way at the top there is this hauntingly awesome area with ropes and pulleys. I'm always discovering a new part of the Pabst that I haven't seen before."

Behind the Glass:
Treasures of Milwaukee Public
Library's Krug Rare Book Room

E ven if you climb the stairs up to the second floor of the Milwaukee Public Library's Central Library, you might miss the Krug Rare Books Room. When you reach the stop of the staircase, the room—which appears dark through the smoky glass even when the lights are on—is behind you.

Inside—in a 5,839-square-foot area that is kept at sixty-eight to seventy degrees Fahrenheit and 40 to 50 percent relative humidity—are more than fifteen thousand rare items, including books, artwork, periodicals and other items, from the six- by six-millimeter Die Kleinsten Bücher series book to Audubon's 435 large Birds of America prints.

The oldest item is a page from a 1240 Vulgate Bible, and some of the most compelling are works that are part of Milwaukee's history, like Harley-Davidson motorcycle manuals and the earliest editions of *The Settlement Cook Book.*

The room's low-profile character is a remnant of an old approach to rare books rooms, said Mary Milinkovic, Arts and Special Collections coordinator at Milwaukee Public Library:

> *For a time* [for] *the whole Special Collections and Rare Book world, not just this library, the main goal was preservation. It just wasn't felt that there was any need to have that information generally accessible. Some of it was just a security thing—you don't advertise something like that—and again that has shifted.*

So okay, there is access to these materials, but we won't promote them. Now that is shifted and MPL with it. We want to provide access, and we're making sure everything is in our card catalog. There's even a part of the catalog that can take you to a list of rarities. We have the Richard E. and Lucile Krug Educational Series; we have speakers come in, and they are talking about either history or sociology or something that is tied into a collection of rare materials.

In 1953, the library's scattered rarities were pulled together into the rare books room—formerly located on the first floor—said Fine Arts/Rare Books librarian Patricia DeFrain. She continued to explain:

Prior to the '50s there were different departments that had maybe a few rare books that they kept secure, but there was no one room where everything was. They were accessible at that time, but separate…little bits of them everywhere all over the library. And the reason [the rare book room] happened is the vision of city librarian Richard E. Krug. He was our city librarian [from 1941 to '83]…and he thought it would be good to have one room that would be secure where this could all be kept.

The current room was opened in 2001—with financial support from Krug's widow—and named in honor of the late city librarian.

On a recent visit, DeFrain and Milinkovic were excited to show off some of their favorite items in the collection, which, though accessible to the public by appointment, is still kept behind glass for safety and preservation reasons.

Some of the gems in the Krug Rare Books Room follow.

Arkham House Collection

"This is an example of one of our special collections," says DeFrain. "This is the Arkham House Collection, a Wisconsin publishing company in Sauk City that was started by August Derleth, the highly prolific Wisconsin author. He was trying to preserve the work of H.P. Lovecraft, but they also branched out to do other horror, occult,

science fiction kinds of things. We put this display together because of the season, you know, the Halloween season, because they've got some interesting covers."

"They were still publishing, as far as we know, through 2006. And I would say we have several hundred," added Milinkovic. "We probably have one of the most complete collections that there are."

HYPNEROTOMACHIA POLIPHILI

"This is not quite the oldest book in our collection, but it's close. It is the *Hypnerotomachia Poliphili* from 1499," said DeFrain. "Someone unknown re-bound it, probably at the turn of the twentieth century, but the pages are all from 1499. It was considered the most beautiful book of the Renaissance; it was the first to integrate pictures in text, and the typography is beautiful…There's architecture, I think agriculture, economic principles, women's rights…There is a lot of stuff woven into it."

GUTENBERG BIBLE FACSIMILE

"This is a facsimile, a really nice facsimile, of the Gutenberg Bible," said DeFrain. "It's similar in size and weight and coloration. This isn't hand-painted, but the original would have been. Anyone who ordered a Gutenberg Bible would get the pages with the black print. Then, whoever bought it would have to hire an artist to illuminate it and do the drawings. This is a facsimile of one particular copy. It's considered a very nice facsimile."

PAGE FROM VULGATE BIBLE

"This is the oldest piece of paper in our collection; it's from 1240," said DeFrain. "It's a page from a Bible written in Latin two hundred years before the printing press was invented. It is part of a portfolio

that was put together in 1923 with one page each from a lot of famous books. This is something you don't see any more on the market, but back then, we would like to think that these books were in bad shape. Instead of not using them at all, they put them into these portfolios. So other people have the same portfolios, but they have different pages from the books."

THE SMALLEST BOOKS IN THE WORLD

"Although this is no longer true, this is called 'The Smallest Books in the World,'" said Defrain, pointing to a small box holding some tiny books, about the size of my thumbnail. "One of them has 'The Lords Prayer,' one has 'I Love You' in nine languages, one has 'The Olympic Oath' and 'The Oath of Freedom.' You kind of need a magnifying glass to read the print. They were made in Mainz, Germany, but I have recently read about books that are even smaller than this. You almost need the tweezers to pick them up. Even with the tweezers, it's difficult to open them.

"This is just an example of a curiosity of book art. Really not practical; nobody's going to really learn much from these because they can't really see it, but it's fun to look at."

DOUBLE FORE-EDGE BOOK

"This is *The Light of the World* by Edwin Arnold from 1891. This is called a double fore-edge book. From the outside it just looks like a nicely bound old book, but if you do this," said DeFrain, bending the book's pages to reveal a painting of a Connecticut scene along the edge, "you'll see it has a watercolor. And this is called a double fore-edge book because if you turn it around, there's a different one. This is an example of the book arts. The book itself is a normal (not especially valuable) book, but I'm sure there are books with double fore-edge that would be valuable, even if they weren't double fore-edge."

Gugler Lithographic Co. Albums

"We have fifty-five sample books that they gave us," said Milinkovic, referring to the long-lived and influential Milwaukee printer. "It's just page after page of stationery and can labels. [Here] is a 1942 transit map [of Milwaukee]."

"I like this one," said DeFrain, pointing to a label that reads, "Creamed Golden Corn, It's Palatable!" "I think they did more stationery earlier on. A lot of labels. Some maps. People get a kick out of looking through it. Who wouldn't want to look at a West Bend White Corn label?"

Our Mutual Friend

"This is something we love to show. When Charles Dickens was publishing in England, a lot of people couldn't afford to buy a whole book," said DeFrain. "They issued them in serial parts, and there were lots of advantages to doing that. It meant the publisher could start getting profits right away, the author could get profits before the book was done and the working man could afford to buy a book every month or so. He might not be able to buy the whole book, but he could afford to buy the serial parts. So this is *Our Mutual Friend* by Charles Dickens. It started in October 1864. There are nineteen, but twenty in all, with volumes nineteen and twenty published together. It's one of my favorite things in this collection."

Romeyn B. Hough's *American Woods*

"The author actually invented the tool to make each one of those thin cuts [of wood]," said DeFrain, flipping through pages with three super-thin shavings of wood to show the grain of each type.

"Each one of those books is unique because each one has a separate scraping of wood," added Milinkovic. "Some of [the types of wood] are close to extinction."

KALEIDOSCOPE

"I believe we have a complete collection of [Milwaukee counterculture newspaper] *Kaleidoscope*, from 1967 to '71. Somebody did the index for just the first volume," said DeFrain. "We always save local periodicals and preserve them, even if they don't make it into rarities. That's a priority, something of local interest. The librarian just recently gave me these issues, and it's nice to share them."

AUDUBON BIRDS OF AMERICA PRINTS

"We just brought out an example of one of the Audubon prints," said DeFrain, showing a gorgeous print of birds on a tree branch. "It's life-size. Mr. Krug got them for us by asking somebody from the Schlitz Brewing Company to buy them for us. He was very persuasive.

One of the most incredible items in Milwaukee Public Library's Krug Rare Book Room is this hefty tome packed with the autographs of famous politicians, statesmen, authors, artists, composers and others.

They used them as kind of educational projects; they framed [them], trimmed them and took them around to schools. I've run into people that remember them hanging in their schools. But then they realized that this isn't the best way to preserve them. They're not supposed to be trimmed. They're not supposed to be framed; they're supposed to be flat and secure in storage.

"In '68, Northwestern Mutual Life gave Mr. Krug a donation to clean them up and store them properly. At the time, we had a refrigerated storage case that they were in. Ever since '68, they've been stored very well. We have the complete *Birds*, which is 435 [prints] and the complete *Mammals*, which is 150 [prints].

"Northwestern Mutual Life made [its] calendar from these. [It] used to borrow a dozen every year and give us some copies of the calendar. But then eventually, a couple years ago, [it] said, 'Let's just take good pictures of all of them.'"

A Book of Autographs

"Now we'll show you one of the greatest treasures," said DeFrain, taking me behind the glass to see a gigantic volume sitting on a reading stand. "You know there are some monuments [out on Wisconsin Avenue], and one is called *The Victorious Charge*. They needed the money to finish it. So a woman named Lydia Ely, a local philanthropist and artist—she was very instrumental in getting the Veterans' Home [built]—her idea was, let's send of these little slips of paper to all these famous people, and they will return them. We will bind all these little papers into a beautiful book, and we will auction off the book. And someone will buy it for enough money to finish off the statue." (A similar approach was used to raise money for the pedestal for the *Statue of Liberty* in the early 1880s.)

The book is quite incredible, both as a piece of Milwaukee history and for the variety and quality of the signatures it contains. Divided into thematic sections—authors, musicians, politicians, architects, artists, actors, etc.—each page has pasted on it a number of the smaller sheets that were returned to Ely.

Among the roughly 2,200 signatures are those of Grover Cleveland, Teddy Roosevelt, William McKinley, Woodrow Wilson, Mark Twain, Booker T. Washington, Thomas Edison, Buffalo Bill Cody, Maxfield

Do not use your morals week-days, it gets them out of repair for Sunday.

Truly Yours,

Mark Twain

Vienna, Sept. 13, 1898.

There are signatures from the likes of Grover Cleveland, Teddy Roosevelt, William McKinley, Woodrow Wilson, Booker T. Washington, Thomas Edison, Buffalo Bill Cody, Maxfield Parrish and Frederic Remington. This one was penned by Mark Twain.

Parrish and Frederic Remington, to name but a varied few. Some musicians wrote little bits of music. Artists drew small pictures; poets wrote verse.

"This one's my personal favorite," said DeFrain. "Lili'uokalani, the last queen of Hawaii, in Hawaiian and English."

"Captain Frederick Pabst bought it," she said. "He paid $800 for it. They finished the statue. We got his library when he died, so that's why we have it."

"Sometimes specialists come through," said Milinkovic. "We had a poet here for our poetry series who came in [while] we were having an open house. She went through the writer's section and was just freaking out, because she had studied and knew these people."

Digging into Wisconsin Architectural History at Milwaukee Public Library

Milwaukee has a rich history and, fortunately, a passion for preserving it, too. Take, for example the Wisconsin Architectural Archive, housed at the Milwaukee Public Library. Founded in 1975 by Thomas L. Eschweiler—yes, of that Eschweiler family—and a few others, the collection, housed within the Central Library's Art & Music department, archives more than twenty thousand architectural drawings by nearly five hundred Wisconsin architects.

Recently, I heard about the collection and decided to check it out. So I went over to meet Gayle Ecklund, an archives technician at MPL, who told me a bit about the collection and showed me some stunning original plans, drawn by Herman P. Schnetzky, of Walnut Street School, which burned and was razed in 1978.

The collection got started, Ecklund told me, when Eschweiler was trying to find a home for the drawings made by his family's famous Milwaukee firm, Eschweiler and Eschweiler. That sparked Eschweiler and his cohorts to actively seek out items for the collection. "They'd drive around in a station wagon to pick up plans," Ecklund said.

Now, folks approach the archive with donations, too.

Sadly, and perhaps ironically since they designed the stunning Central Library building itself, there are few works by George Ferry & Alfred Clas. This is because, said Ecklund, the story—perhaps apocryphal because the Pabst Mansion collection contains a stash of Ferry & Clas drawings—goes that after a balcony collapsed in one

Herman P. Schnetzky's Walnut Street School doesn't survive, but the architect's renderings do, in the Wisconsin Architectural Archive housed at Milwaukee Public Library.

of their buildings, the architects feared liability issues and burned all their drawings.

I was pleased to see that Henry C. Koch, who designed many prominent Milwaukee buildings, is fairly well represented. The collection holds Koch's plans for city hall, Turner Hall, Gesu Church, the old South Division High School and a few other works.

There is a searchable, computerized index to the collection; however, it is not yet accessible online. To use the collection, call the Frank P. Zeidler Humanities Room to see if the archives have what you're looking for. If so, Ecklund can pull the drawings and make an appointment for you to look at them.

Ecklund says the archive gets anywhere from 150 to 300 requests annually. Many are from folks searching for plans for or more information on their homes. Copies of drawings are available for a fee.

The WAA is a great historical archive housed in the heart of Milwaukee; we're lucky to have it.

Tower Automotive Site Reflects Changes in Milwaukee

For decades, the eighty-plus acre tract of land between the train tracks and Hopkins Avenue bustled with activity. As many as ten thousand workers for A.O. Smith from 1910 to 1997—and Tower Automotive from 1997 until 2006—worked there in dozens of buildings. They built car frames; made pipes, hot water heaters, airplane propellers and vats for breweries; fabricated bomb casings during World War I; and many other things over the years.

The City of Milwaukee bought the site east of the tracks in 2009, according to Benjamin Timm, the city of Milwaukee Department of City Development's project manager for the Thirtieth Street Industrial Corridor, of which the site is a part.

"The city was very concerned about what would happen with this because of the impact it would have on the North Side of Milwaukee," he said.

Now, a mere handful of buildings still stand, and a couple of those—some small utility buildings—will likely have fallen between the time I write this and when you read it.

"We started doing structural assessment of the buildings, environmental assessment and ultimately cleanup and demolition of the buildings," said Timm. "We originally looked at all the buildings out here to see if we could keep some standing. Basically, what's in good shape, what could stay and what could go. Ultimately, this whole facility was meant to function as a single unit. So it's very difficult to break these buildings apart and let them stand on their own, so we decided to tear everything down."

A dozen, maybe two, bulldozers and excavators are on the old Tower site east of the tracks working to ready it for future industrial development.

On the south end, in a long building along Townsend Street, Spanish train manufacturer Talgo was, in 2012, finishing up some train sets destined for Oregon—one rode the rails out in early December 2012 and, by midmonth, another was parked out on a siding—before the company finished ramping down and closing. Two sets for Wisconsin were inside the building.

The seventy-acre parcel of land west of the tracks that was long part of the A.O. Smith/Tower Automotive complex is divided up and controlled by various owners. The City of Milwaukee owns a large portion that serves as a Department of Public Works facility.

Two of the buildings still standing on the city's land to the east are the two-story 1910 A.O. Smith headquarters and adjacent to it, to the south, the 1930 Research & Engineering building, which offered a light-filled workspace for its four hundred engineers. (By 1910, A.O. Smith, which started out as a bicycle manufacturer in Walker's Point, was making automobile frames for Henry Ford.)

The two-story red brick 1910 building with its decorative gable and curly-cues flanking an engraved "A.O. Smith Co." nameplate above the entrance is being preserved. According to Timm, there has been some interest from the private sector in this building. There's almost nothing left of the original interior. A decorative railing runs up a staircase, a curved glass window wraps itself around a cut-off corner along a hallway. The one major exception is a first-floor corner conference room with a fireplace, rich wood paneling and leaded glass windows, which have been bordered up for protection. Timm says estimates at rehabbing the building have run around $1 million.

Unfortunately, estimates for its seven-story neighbor run somewhere in the range of thirty to fifty times higher. This structure—designed by the Chicago firm of Holabird and Root—was not only the first multistory building with full-curtain walls of windows made of large plate glass in aluminum frames but also the first to use extruded aluminum and one of the first multistory International Style buildings constructed in the United States. Despite its disrepair, which is clear from the netting that's been attached to prevent falling shards when the windows burst outward (as has occurred), the building is clearly a gem, with its beveled rows of windows running from ground to roof—six on the façade, eight on the south and north sides—flooding the interior with light.

Work continues on preserving A.O. Smith's 1930 Research & Engineering building, designed by Chicago's Holabird and Root. At press time, the building was undergoing asbestos remediation. *Courtesy of Historic Photo Collection, Milwaukee Public Library.*

But those gigantic windows aren't the only source of natural light in the U-shaped building. In the space created by the sides of the U is a giant open interior space that is two stories tall, with a grid of small windows serving as an arched skylight. A giant overhead crane—one of hundreds that were on the site—running on rails was installed in this research and development lab space. It's still there, though it's dormant now. In the terrazzo in this giant space are rows of metal rings that helped add strength to the floors.

"It wasn't built with energy efficiency in mind," said Timm of the R&D building. "Lots of natural light, but it's basically metal and glass, and [those are] the only thing[s] separating the outside from the interior. Both metal and glass do a good job of conducting hot and cold."

We entered the building through a door in the back, and so we saved the first floor's biggest treat for last. The lobby, which isn't huge, is perhaps

the most beautiful Art Deco space in the city. Decorative aluminum Art Deco sections share the walls with glossy emerald panels and matching aluminum doors. Walking into the space, with its terrazzo floor that includes a multicolor decoration punctuated by translucent areas once lit from below, feels like stepping into a long-lost work of art. Should this building ever be demolished, I hope someone has the foresight and the ability to remove the lobby piece by piece and reconstruct it elsewhere. It is that gorgeous.

Off the lobby is a large conference room. Wood paneled, it looks like a set for television's *Mad Men*. Almost hidden in the wall is a door to the men's room.

Upstairs, in what was office space, the areas are large, with those giant windows—each one a single pane of quarter-inch glass nine feet wide by thirteen feet tall—along the exterior walls. Some floors are in better shape than others. On one floor, it almost looks as though folks moved out last month. On that one, a discarded little Christmas tree lays on its side on the floor, still wearing decorations. On another, it feels like the '80s with walls that alternate between pink and turquoise.

In a small office, there are boxes and boxes of discarded files, still on the shelves. A membership booklet for an industrial union sits on a desk. Outside an office on another floor is an old issue of *Penthouse* magazine.

As you ascend to the higher floors, the lack of heating and cooling systems (they were located in a now demolished adjacent building) has taken its toll. The parquet floors are buckling, creating long strips of elevated flooring, poked up in an upside-down V shape.

We climbed to the roof—passing through an HVAC space as quickly as possible because there is still friable asbestos in there—and were treated to some great views. Everything on this side of town is low enough that you can see distant landmarks in every direction: to the southwest, Miller Park and Froedtert Hospital; downtown to the southeast; off to the northeast, Bayshore; and far off on the horizon, Holy Hill. To the northwest we can see the two glass office towers near Good Hope Road and Highway 45 where A.O. Smith's headquarters are now located. We also got a great view of the entire Tower Automotive site from up here. It was amazing to see how the site's many buildings—most of which had been built into and on top of one another, though some were connected by above-ground passages and others by tunnels (workers uncovered all kinds of underground bomb shelters, torpedo factories and the like)— have been cleared.

The city has completed a lot of work on the site and is working now on moving into the future with its master plan.

"We're starting a full-scale marketing initiative in 2013," said Timm. "When we started this project and people would drive down Hopkins, all they'd see is a wall of buildings. You're telling them what you're doing; you can tell them your vision, and they're standing there saying, 'You're crazy.' Now they can come and see eighty acres of open land; now people are starting to get it."

Brewing Up Milorganite

Let's get this straight from the get-go. Despite what you've heard, Milorganite is not made out of human feces.

On a recent tour of the Jones Island plant, Milwaukee Metropolitan Sewerage District agency services director Jeff Spence and public information manager Bill Graffin dispelled that myth. It is sort of true, however, if you believe that you are what you eat. Let me explain.

Three thousand miles of household laterals and another 3,000 miles of sanitary sewers send water and liquid waste to the MMSD via the sewer system. The deep tunnel project, which is 28.5 miles long, serves as an overflow storage system that can hold up to 521 million gallons. The water is pumped to two plants—one on Jones Island and the other in Oak Creek—and at Jones Island, it first undergoes a screening process that removes objects of all sizes, like towels, gravel and sand. That water then moves to a series of circular holding tanks for a process called primary clarification. Here, solids sink to the bottom, and oils and grease rise to the top for skimming.

The next step is where Milorganite (a smashing together of Milwaukee Organic Nitrogen) really begins to happen. The water flows from the primary clarification pools to long storage channels where biological treatment takes place. These pools of churning water are murky, and tiny solids can be seen—but that's not human waste. It's bacteria—like aspidisca, arcella, vorticella and others—that breaks down the organic material in the water.

Despite what you've heard, Milorganite is not made out of human feces. It is, however, made from the bacteria that feasts on feces.

As we gaze at the water, Graffin explains that the murkiness is the coagulation of the microscopic bacteria, which live a very short life span in the water. About a fifth of the bacteria comes out to enter the Milorganite-making process and the rest is reintroduced to the churn.

So Milorganite is actually the dead bacteria, not poop (though that is the bacteria's food).

"The bacteria require a tremendous amount of air, and that's where most of the energy cost comes from, pumping these big tanks full of air," said Graffin.

Behind us is a low building with a sign that reads, "Mixed Liquor Gallery." Spence and Graffin chuckle graciously at my booze jokes as if they hadn't heard them a million times before, and then Spence explained:

> South Shore is a different kind of plant; it's an anaerobic digestion plant. So what we have down there is a breakdown of solids, digested solids. They're shipped back up here. Milorganite is made of two different types of sludge: digested and waste-activated. You've got flows coming in—water that's processed here and water that's processed at South Shore—and it comes together [in the Mixed Liquor Gallery] in a certain percentage and all those bugs make up Milorganite.

Entering the manufacturing building—it's the big one you can see from the Hoan Bridge and from Summerfest, with the big smokestack on top—I'm immediately reminded of the industrial scenes in Antonioni's film *Red Desert*. There are rows and rows of pipes of all sizes, the din of machinery and darkness illuminated by a yellowish light.

"I just marvel at this place from an engineering perspective," said Spence. "For something that seems so simple, there's so much that's going on here."

"As you walk through you'll see a lot of duplication of systems, from filter beds to dryers," he continued. "There are twenty-four belt filter press beds, and we've got twelve dryers. And it can all be managed depending on flow; how much you've got coming into the plant. We don't get to run twelve dryers until the heavy season, which is from January through April or May [when] we have so much flow coming through. There's a lot of redundancy…to deal with volume."

Spence added that the repetition of systems also allows the plant to run continuously while being able to keep everything in good working order, too. The Milorganite itself is extremely abrasive and takes a toll on machinery, requiring constant upkeep.

During summer, the plant produces an average of around 105 tons of Milorganite a day. During other parts of the year, that average can go up to nearly 200 tons per day. MMSD expects to make about 45,000 tons of Milorganite this year.

Milorganite was first sold for commercial use in 1926, and its popularity soared in the following decades. It is now sold across the United States, Canada and the Caribbean. It exceeds the criteria for the EPA's "Exceptional Quality" rating and is certified by the USDA because it is made from renewable sources. Its production is among the largest recycling programs in the world.

I expressed my surprise at how few people I'd seen so far, both outside and inside, and Spence said, "It's such a large facility, but you don't see a lot of folks. Most of the folks you'll see are maintenance folks, repair guys." Graffin added that there are about 220 employees here. Scientists and other employees work at MMSD headquarters on Seeboth Street in Walker's Point.

We headed to the top of the building and worked our way back down. From the roof—which offers amazing views of Milwaukee in every direction—the Hoan Bridge seems almost so close you could reach out and touch it. It also provides a perfect place to get an aerial view of the systems

at the Jones Island plant. Up here, there are solar panels, which help run the plant. Recaptured methane is also used to defray energy costs.

After I snapped more than a few pictures and got an "aerial tour" of the plant, we went back inside, passing a floor with a relatively low ceiling. On the access door, which is partially ajar, there was a plain engraved sign that read, "Penthouse."

We stopped to view the belt filter presses first. Here, a series of wide, flat beds are covered in Milorganite. It's sopping wet on one end and almost completely dry on the other. The water is pressed out so that less than 10 percent moisture is maintained. At the end, rollers squeeze out some more, dropping the product down a few floors to the dryers. Twelve dryers may not sound like much, but each dryer is a giant horizontal cylinder that looks like it might be longer than your average freight rail car. The noise and the heat in this part of the plant verge on intense. Here, I finally got an answer to a question I've had since I was a child visiting my grandparents on the far end of Walker's Point: "What's that smell?" That corn-ish, somewhat acrid odor is the scent of Milorganite being made!

Graffin led us to the north end of the first dryer, where there's a round door that reminded me of a coffee roaster. He opened the door, and we could see the nearly finished Milorganite swirling around. Sticking in a ladle, he drew out some pellets, and I could see that they are not uniform in size. Different sized pellets are destined for varied uses. Tiny ones—or greens grade—work perfectly on golf courses, bigger ones are good for residential/retail use and some Milorganite is sold to other manufacturers, too.

"We sell different nitrogen percentages to those markets, as well," said Spence. "So at some points of the year, we produce a product that's 6 percent nitrogen. At this time of year, we can't get to 6, and we don't add anything to get it up to 6. So we market it as 5 percent nitrogen."

He further explained: "Nitrogen content is an effect of what's coming in, and with any treatment process, you've ammonia coming off it that's carrying away nitrogen. At hotter times of the year, ammonia's coming off at [a] faster rate, so you've got less nitrogen."

Inside the plant, everything is monitored by two workers—the day of my visit, they were both named Andre—seated in an air-conditioned room full of screens monitoring the facility.

Outside, we can see the silos that store the finished Milorganite, and like agricultural silos, care must be paid here to avoid hot spots. Next to the silos, a covered hopper car is ready to be filled with Milorganite.

The water that came into the plant at the start of the process is returned to Lake Michigan after it was disinfected and neutralized upon leaving biological treatment. Often, a gathering of fishermen in boats—especially at South Shore—marks the site of the outflow, where the warm water attracts fish.

When we stopped to see the site of the outflow on Jones Island, we peered into one of the pools of water waiting to go back to Lake Michigan. A seagull floated on the water's surface. Spreading its wings, it lifted itself into the air, leaving behind a contribution of its own. The water is now truly ready to go back to Lake Michigan.

Eschweiler Buildings
Threatened with Extinction

From the view I usually have of them, the four remaining Agricultural College buildings designed by Alexander Eschweiler and erected on the County Grounds in 1911–12, are a mystery. They're perched above Tosa's Swan Boulevard in a position that suggests respect. But they're also obscured from the road, peeking out from a screen of trees and overgrown tangles of weeds, lurking like escaped prisoners hiding from their fate.

The buildings, which are on the National Register of Historic Places, were constructed to house the Milwaukee County School of Agriculture and Domestic Economy, but that institution proved short-lived. Barely a dozen years after they were built, they became vacant.

HGA architect Jim Shields, who worked with the Mandel Group on a plan to build apartments on the site, told me on a visit that nine or ten years later, the buildings began to house kids from the Milwaukee County Home for Dependent Children, across the prairie to the south, near Ninety-fourth and Watertown Plank Road.

And that was pretty much the foundation of the story for a century. The buildings were occupied for a while, then vacant for a while, occupied for a while, vacant for a while. They've been silent again for more than a decade. Though while the buildings have echoed with little more than the hiss of vandals' Krylon cans and the thrum of traffic from nearby I-45, Wauwatosa and Milwaukee have buzzed with discussions about the fate of these structures.

One proposal, floated by the Mandel Group, is to buy the property from UWM, which is building a research campus on adjacent land, and erect five buildings of apartments. Eschweiler's engineering building would be razed, his stellar administration building would be renovated into a commons building—with an exercise room, meeting space, etc.— and the dairy and dormitory buildings would be in large part demolished, though their exterior walls would remain up to the string courses and serve as borders for a pair of walled gardens. This plan conjures images of those roofless, dilapidated abbeys one sees dotted around Yorkshire, where the remaining walls hem in overgrown vegetation or carefully tended lawns. It calls for more formal gardens, however, not just random weed growth or putting-green grass. There is opposition to this plan, however, because it fails to preserve all four buildings. Others oppose it out of concern for the effect the entire development could have on an adjacent monarch butterfly habitat.

My visit was both exciting and disappointing.

All four buildings are lovely on the outside, with Eschweiler's variegated brickwork, augmented by fetching patterns. One of my favorite views is an area between the dorm, dairy and engineering buildings, where you can see that the architect created a theme of triple dormers but chose a different arrangement for each of the three buildings. Also quite alluring is the "quad," or the area surrounded on two sides by the administration, dairy and dorm buildings. One is instantly transported to the corner of Hartford and Downer Avenues and its quad bordered by some finely preserved Eschweiler buildings, and the imagination runs wild with possibilities for this site.

Inside, things are a bit different. I was disappointed to find that the dairy, dormitory and engineering buildings are in sad shape in terms of condition. I could see the shimmering reflection of standing water on the roof of the dairy, brick is exposed on inside walls and the connecting heating tunnels have filled with water repeatedly, for a start. Certainly, these buildings can be repaired, at a cost. But it is notable that whatever interior architectural elements were present when the agricultural college opened have since been stripped clean. Instead, there is thick carpeting, altered wall configurations, dropped ceilings and linoleum tiles on the floors.

Inside the administration building, which we visited first, things are different. The stunning disrepair is the same. I saw daylight in one room, and when I went to investigate, I saw I could easily climb through the hole in the roof allowing the sunshine (and certainly rain and wildlife)

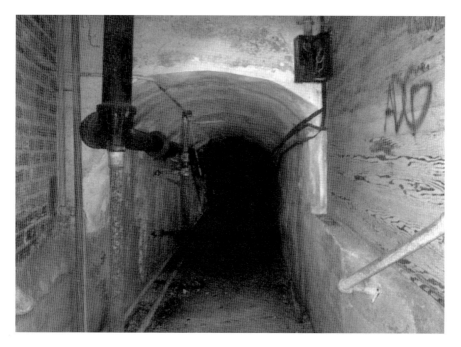

The remaining four Milwaukee County School of Agriculture and Domestic Economy buildings are connected by tunnels. Though they're big enough to walk through, these tunnels were built for steam heat, not pedestrian traffic.

to enter. But this building remains a gem. There are hardwood floors, stained moldings that have deepened to a rich hue over the years and fine staircases leading up to a third-floor gym that is perhaps the most beautiful I've ever seen, with pointed arches running the length of the room and balconies on opposite ends. Though they've been boarded up, the skylights that must have flooded this gorgeous space with light are still there.

While it broke my heart to see the condition of the administration building, it was thrilling to imagine it restored to its former glory, and because so much of its original detail is still there, it was eerie to feel the vibes of the feet—big and small—that walked these same hardwood floors over the course of a century.

Plans for the buildings come and go, and so do the vandals, the rodents, the wind, the rain, the ice and the searing summer sunshine. And it is plain to see that the boards over the windows and the signs threatening video camera surveillance are doing nothing to ward off any of them.

Index

About the Author

Robert Tanzilo is managing editor at OnMilwaukee.com, a daily online city magazine. Born and raised in Brooklyn, New York, he now lives in Milwaukee. He is the author of four previous books, including two published by The History Press.

Courtesy Andy Tarnoff.

Visit us at
www.historypress.net
..
This title is also available as an e-book